Lives of the Artists

ANDY WARHOL

Robert Shore

Laurence King Publishing

For Hector, Muriel and Kathleen B.

LAURENCE KING

Published in 2020 by
Laurence King Publishing Ltd
361–373 City Road
London
EC1V 1 LR
United Kingdom
T + 44 (0)20 7841 6900
enquiries@laurenceking.com
www.laurenceking.com

A catalogue record for this book is available
from the British Library.

ISBN: 978-1-78627-610-0

Printed in Italy

Laurence King Publishing is committed to ethical and
sustainable production. We are proud participants in
The Book Chain Project®
bookchainproject.com

**BOOK
CHAIN
PROJECT**

Cover illustration: Timba Smits

CONTENTS

Prologue
First Death

I t was 4:15pm on 3 June 1968 and Andy Warhol's life was about to change forever. Dressed in his customary uniform of black jeans, T-shirt and leather jacket, the Pop Art king hopped out of a cab and danced lightly past the drug dealers in Union Square on his way to his studio, the Factory. His mind was teeming with fresh projects – films about gay cowboys and hustlers, a novel to rival James Joyce's *Ulysses* – and the influential critic and curator Mario Amaya was waiting in his studio to talk to him about a possible retrospective in London. Warhol was not very interested in the idea of retrospectives – it was boring to show old art, and anyway, he had retired from painting to make films – but all publicity was good, right? And if it pushed up his prices, that was good too. You had to bring home the bacon.

The Factory at 231 East 47th Street had been a legendary New York countercultural hangout, a silvery den of unprecedented social freedoms, where uptown millionaires mingled with downtown boho misfits. A movie camera documented the heterogeneous sexual shenanigans being enacted on the famous red couch salvaged from the sidewalk, and the house band rehearsed cacophonous songs about S&M and drug abuse at ear-splitting volume. Art was made there too, of course: silkscreen paintings of humble grocery items and glamorous film stars poured from its assembly line – it was not called the Factory for nothing. But amphetamine-fuelled excess had spawned a contagion of madness, and things had had to change.

So today Warhol was heading to his new Factory, where the carnivalesque liberties of its predecessor had been carefully curtailed. Located at 33 Union Square West, it was altogether more business-like in character: soberly decorated, it even had a polished wooden floor. At twin desks by the door sat Fred Hughes, Warhol's business manager, and Paul Morrissey, his movie-making collaborator. Both were recent recruits to the team, and neither had any taste for the chaos of the Silver Factory. Indeed, the Jesuit-schooled Morrissey had a strong moralistic streak and was one of those who had warned his boss that if he continued to keep such dubious company something terrible was sure to happen. Morrissey did enjoy gossip, though, and now sat chatting on the telephone to Viva, one of Warhol's Factory-made 'superstars', who was calling from the chic uptown hair salon Kenneth, where she was having her locks tended ahead of shooting a scene for John Schlesinger's film *Midnight Cowboy*.

At the front door of the building on Union Square, with Stevie Wonder's 'Shoo-Be-Doo-Be-Doo-Da-Day' blaring from a radio beside him, Warhol greeted his new assistant, Jed Johnson, who was also making his way in carrying some fluorescent tubing. As they started to talk, Warhol physically impassive as ever but his eyes animated – Jed was his new boyfriend – they were joined by a third figure. This was Valerie Solanas. Warhol had always been wary of her. She had wanted him to produce a script she had written. Called *Up Your Ass*, it was so outrageous Andy thought she must be an undercover cop trying to entrap him. Solanas had also written a manifesto arguing the need to 'eliminate the male sex'. Today he noticed that, although it was June, she was wearing a heavy winter coat. She held a brown paper bag and was twisting it anxiously in her hands as they all got into the freight elevator and pressed the button for the sixth floor.

Morrissey was still talking to Viva as the trio entered the Factory. He greeted Solanas again – this was not her first visit that day – and left the phone receiver for Warhol. He and Johnson headed for the back of the space as Warhol took over the call with his superstar. For a moment all was still. Then –

Bang!

Solanas had drawn a .32-calibre automatic pistol from her paper bag, taken aim at Warhol and pulled the trigger.

Then she fired again. And again.

Warhol had fallen to the floor at the first shot, but it was the third that caused the damage, tearing through the right side of his chest before exiting via his back. Solanas watched as blood pumped from his chest and satisfyingly soaked his T-shirt. Now she turned in search of other victims. The praying figure of Mario Amaya was next. Fred Hughes begged, 'Please don't shoot me, Valerie,' as she pressed the gun to his forehead. Then the elevator jolted to a halt behind her and she heard Hughes telling her to get in. No longer sure what she was doing, she obeyed.

Twenty-three minutes later, the Emergency Medical Services delivered the wounded artist, unconscious, his pulse fading, into the emergency room of Columbus Hospital on East 19th Street. He was taken straight into the operating room. At 4:51 on the afternoon of 3 June 1968, Andy Warhol, Pop Art's great chameleon, was pronounced dead.

1

The Alien from Pittsburgh

A ndy Warhol might have grown up to be a priest. That was what his older brother John said, anyway. It was not something that Andy said – but then Warhol was a notoriously unreliable witness when it came to himself, particularly his childhood. After he became famous, when he talked to interviewers he would vary the date of his birth and announce that he came from McKeesport or Philadelphia, or even Hawaii; he actually came from Pittsburgh, the smog-blanketed steel capital of the USA – an industrial city full of factories. Given this introduction into the world, it is perhaps unsurprising that he would call the successive incarnations of his own artist's studio the 'Factory', and would find it natural to construct an assembly line of collaborators and employees to make his art.

He came into the world on 6 August 1928, the last of three brothers born to Ruthenian immigrant parents, and was christened Andrew Warhola. The family lived in a two-room row house apartment at 73 Orr Street, in a slum district of Pittsburgh on the banks of the polluted Monongahela River. Space was in short supply, so the brothers shared a single bed. Their parents, Julia and Andrej, had settled in the USA after growing up in Miková, a village in the Carpathian Mountains, and they communicated at home in a dialect of Carpatho-Rusyn. Andy only learned English at school and in early life spoke it with a heavy accent, which caused him embarrassment and increased an already marked natural shyness.

The Warholas lived in a Central European ghetto; mainstream modern America was geographically close but culturally, linguistically and spiritually distant. The boys were raised in the Byzantine Catholic faith and regularly attended St John Chrysostom Church, where they listened to services in Old Slavonic. Andrej would lead the family in communal prayers before meals, and every morning and night Julia oversaw their private orisons. The Great Depression struck the year after Andy's birth, so making ends meet was always a struggle, and Andrej travelled significant distances to find work. Sometimes the boys' tomato soup had to be made by stirring ketchup into boiling water.

Julia made very few concessions to American life. Eccentric and superstitious, she wore peasant dress and liked to weave dramatic yarns about her early years in the old country. She was never comfortable speaking English, and mangled the words so badly when she read to her little Andek from his comic books that he had difficulty following the action. But she had a beautiful singing voice and an artist's hand and eye, making floral bouquets from empty cans and crêpe paper and selling them door to door: 'that's the reason why I did my first tin-can paintings,' her youngest son would later say.

From his father, who did construction jobs, Warhol got his extraordinary work ethic and learned the importance, as he enjoyed telling people, of 'bringing home the bacon'. Then there were the gallbladder problems that would dog Andy in later life; those perhaps came to him via his father too.

In 1934, the family moved to a nicer home on Dawson Street in South Oakland that Andrej, through his hard work, was able to buy for cash, and Andy began to attend Holmes Elementary. Their new neighbourhood may have been more upscale, but it was still not especially sanitary, and rheumatic fever was rife

among the local children. Never a particularly healthy or active boy, Warhol developed the condition in 1936 when he was eight; it turned into chorea, or St Vitus' Dance, a disorder of the central nervous system, which made him shake. (In later life, he would say that he had suffered a nervous breakdown.) His classmates mocked his trembling form and the doctor prescribed a month in bed. His doting mother took the opportunity to shower her invalid boy with little gifts: comics, colouring books and movie magazines. There were also paper dolls to cut out, which Warhol later described as his first works of art, and a Hershey bar as a reward for completing his drawing assignments. Acquired in early childhood, Warhol's sweet tooth would remain with him throughout his life.

Andy loved the cinema. Every Saturday morning, eleven cents secured him an ice cream and a double feature at the local movie house. He was also in the habit of writing off for autographed photographs from Hollywood stars, which he kept in a special scrapbook. Now, as he lay sick in his room, he surrounded his bed with their portraits, immersing himself in their world of glamour and celebrity. He understood the romance of Hollywood as only an outsider could.

Nineteen thirty-six, the year of eight-year-old Andy's attack of St Vitus' Dance, also brought the release of *Poor Little Rich Girl*, which starred the eight-year-old Shirley Temple. In the film, Temple plays Barbara Barry, who, neglected by her widower father, pretends to be an orphan, falls in with vaudeville performers and becomes a radio star – before being reunited with her papa. Warhol loved the film and idolized Temple, imitating her gestures and adopting her as a kind of female alter ego, the first of many in his life. He wrote to her fan club and, in return for payment of a dime, received a portrait signed 'To Andy Warhola from Shirley Temple'. This became his most

prized possession, and was given a page to itself in his scrapbook.

The young Warhol's drawing skills were spotted early on, and at the age of nine he was recommended for the free Saturday art classes at the Carnegie Institute. As well as the beginnings of an art training, these lessons provided Warhol with a view of a wider social scene than his otherwise narrowly ghettoized upbringing allowed: *le tout* Pittsburgh was on display when he traipsed to the Institute on Saturdays.

In September 1941, Warhol started at Schenley High School. Bright but highly strung, he had developed a skin condition that made him look pale and blotchy, so some boys called him 'the albino'. He was also self-conscious about his bulbous, increasingly ruddy nose, another inheritance from his father; his brothers teased him with a refrain of 'Andy the Red-Nosed Warhola'.

In the year that Andy began high school, his father died. While away in West Virginia, Andrej had drunk contaminated water and never recovered. In accordance with traditional religious practice, the body was laid out in the family home for three days, but his youngest son refused to look at it, hiding under a bed and weeping uncontrollably. Andrej's was seemingly the only funeral he would ever attend. Two years later, Julia was diagnosed with colon cancer and spent six weeks in hospital, during which time Andy prayed devoutly for her. She survived, but was left with a colostomy bag. Young Andy made up his mind to avoid hospitals as much as he could.

In 1945, just as World War II ended, Andy fulfilled his father's ambition for him by enrolling at the Carnegie Institute of Technology on a course in pictorial design and becoming the first Warhola to attend college. Bauhaus principles, breaking down the distinctions between fine and commercial art, ruled there – ideas that would find expression again at the Factory and in Warhol's philosophy of art as business.

Warhol became friends with his fellow student Philip Pearlstein, who was four years his senior and had begun at Carnegie Tech in 1942 before being drafted into the army and posted to Italy. Pearlstein's precocious painting skills had been celebrated in *Life* magazine when he was only fifteen years old, which had made him something of a Pittsburgh art star. Warhol was fascinated by his fame. He set up his easel next to Pearlstein's in a painting class and asked him: 'How does it feel to be famous?' Pearlstein replied: 'It only lasted five minutes.' Already impressed by the glamour of celebrity, Warhol joshingly began to call Pearlstein a 'has-been' – although this would prove not to be the case, as his friend would find fame again in the coming decades as a leading American realist painter.

Andy was developing dandy tendencies, dyeing his hair green and painting his fingernails different colours. He was also taking tentative first steps in two new pursuits: dance and window dressing. Interested in ballet and modern dance, he joined the Modern Dance Club at college; photographs show him and his friends playfully parodying Martha Graham's celebrated performance in *Appalachian Spring*. He did not warm to pliés but developed a distinctive dancing gait, and dancers featured in a Christmas card (signed 'André') that he produced at this time. He also took a part-time job at Pittsburgh's premier department store, Joseph Horne's, where he painted backdrops for windows and befriended display director Larry Vollmer, who had worked with Salvador Dalí on a window at Bonwit Teller in New York. Dalí was not above commercial work, and neither would Warhol be.

According to Pearlstein, Andy's spell at the store also provided him with the most essential part of his art education: Horne's workshop gave him access to all the new fashion magazines, the layouts of which he studied in great detail. 'He became a connoisseur of the printed page, a student and eventual master of the visual effects produced by the mechanics of printing,' Pearlstein remembered.

Andy put his insights into practice as art director at *Cano*, the college literary magazine.

The approach of graduation presented a choice. The path was open to Warhol to become an art teacher in Pittsburgh; that way he could live close to his mother. But encouragement from a Carnegie Tech teacher, the painter Balcomb Greene, made both him and Pearlstein think seriously about taking the more hazardous course of pursuing a career in the country's commercial and artistic capital. Warhol was a trained commercial artist now, and the magazines that would need his services were all concentrated there. There was only one conclusion to be drawn: success would be a job in New York.

2

The Rise of the Raggedy
Commercial Artist

If you wanted to sum up Andy Warhol's first decade in New York in a single word, you could do worse than plump for 'shoes'. The footwear theme was set on his second day in the city, when the aspiring commercial artist pulled on his old sneakers, gathered up his portfolio and set out for the Condé Nast building on Madison Avenue, which was home to some of the biggest and glossiest publications hawking the American Dream to the new consumer society. Warhol secured a meeting with Tina Fredericks, the art director of *Glamour*, who straightaway commissioned him to do some drawings of fashion shoes for women – and in the process defined his signature subject for the next ten years.

The association with Fredericks and *Glamour* – the magazine 'For the Girl with a Job', as its tagline proclaimed – would also provide Warhol with a new identity. His first credit in the magazine, for an article appropriately entitled 'Success Is a Job in New York', would give his name as 'Warhol', without the final 'a'. Henceforth it would be under that moniker that the shy immigrants' child from the provincial slums would practise his art. Andy Warhola was no more.

If the shoes he was paid to depict were glamorous, the tiny, insect-infested walk-up apartment on St Mark's Place that Andy moved into with Philip Pearlstein in June 1949 was quite the opposite. According to Pearlstein, 'The bathtub was in the kitchen and it was usually full of roaches, incredible roaches.' Andy later recounted having one of the insects steal out of his portfolio while the legendary fashionista Carmel Snow, editor of *Harper's Bazaar*, was perusing his work. Snow

was associated with the mantra 'Elegance is good taste, plus a dash of daring' – and perhaps Warhol was serving up that recipe for her by supplementing his undeniably elegant drawings with a surprise appearance from a roach.

Warhol certainly knew how to make an impression. It was hot that June. 'On his first appointment, he told the receptionist that he was about to faint and asked for a glass of water,' Pearlstein remembered. 'The whole staff scurried around to make him comfortable. He wondered if he could use that routine again.'

Warhol worked up lots of little tricks to ingratiate himself with clients: making little gifts to receptionists or running errands while waiting for an art director to see him. At the same time, the first of a series of personas Warhol would adopt in the coming years began to emerge: 'Raggedy Andy', an elfin presence who wore thick spectacles and old shoes, carried his drawings around in a brown paper bag (another nickname for him was 'Andy Paper Bag'), and spoke in a breathy, unemphatic voice that made you feel protective towards him.

Warhol's work was as distinctive as his manner. At Carnegie Tech, he had discovered the 'blotted-line' drawing technique that would give his commercial work its unique look. This process involved hingeing two sheets of paper together with a bit of tape – or simply folding a single sheet in half – then making a pencil drawing on the right-hand side and gradually inking and transferring it to the left, giving the resulting work a distinctive 'blotted', and indeed printed, look.

It was a time-consuming process – Pearlstein soon grew used to his roommate's all-night work sessions – but it allowed Warhol to produce a number of versions of each drawing, all of which he would colour differently. This allowed him to present art directors with a series of variants, which made him very popular. His efforts were quickly rewarded: commissions started flowing in for magazine features, book jackets, commercial pamphlets and album covers, all

of which he fulfilled with a workaholic's gratitude and dedication. He drew the clouds and sunshine on NBC's morning weather map; his hand could be glimpsed on television.

Back in Pittsburgh, Warhol's mother had regaled him with the cautionary tale of Bogdansky, a Ruthenian artist who had dared to try to conquer New York and had ended up dead in a gutter. A visit to New York now convinced Julia that her Andek was living badly – his clothes were dirty and he seemed to subsist only on candies. So, in the autumn of 1952, shortly after he had moved into a new basement flat on Third Avenue – Warhol was doing well enough financially to be able to afford a place of his own for the first time – she appeared at his door with her suitcases and announced that she had sold the Dawson Street family home and planned to move in with her youngest boy until he had found a nice young woman to settle down with. By way of response, Andy said that she could stay until he had had a burglar alarm fitted. In the event, she would run his household almost until her death, twenty years later.

The conditions in their Third Avenue apartment were cramped and noisy – it was under the elevated train tracks on East 75th Street – and the pair were forced to share a bedroom, each having a mattress on the floor, while the kitchen was pressed into service as Warhol's studio. They were soon joined by two Siamese cats, Hester and Sam, who across the coming years multiplied into a posse of twenty or so.

Warhol had an instinct for personal myth-making, and was quick to incorporate his mother, with her penchant for wearing babushka-style peasant dress and speaking a Central European dialect, into his legend. Their personalities intertwined in complicated ways: they lived, prayed and even worked together, Julia providing the lettering for Andy's illustrations – she was responsible for the signature that appeared on his work. Sometimes she would claim actually to *be* Andy Warhol, while at others she subsumed her identity into his by

working professionally under the name 'Andy Warhol's Mother': Julia understood the commercial value of a good brand.

In 1953, Warhol was introduced to Fritzie Miller, an agent and publicist, who would help to establish him as New York's most in-demand illustrator of women's accessories. A major breakthrough came in 1955, when he was commissioned to illustrate a series of newspaper ads for the fashionable Manhattan shoe store I. Miller; the campaign would run for years in the society pages of the Sunday edition of the *New York Times*. 'The strength and sparseness of Andy's work took people's breath away,' explained the store's vice president, Geraldine Stutz.

With the advertising industry in boldly expansionist mode – selling the American Dream was a $9 billion-a-year enterprise – and magazine titles proliferating, commercial art was a good place to be. By the time Warhol was twenty-five, he was earning $25,000 a year, six times the average US family income at the time. His annual income gradually rose to $100,000; one year, the I. Miller account alone brought in $50,000. Warhol had to hire assistants: first Vito Giallo, then Nathan Gluck, who would exercise a decisive creative influence. Warhol's factory-style production model was already taking shape.

In emotional terms, it was time for Warhol to move on from his childhood Shirley Temple fixation. He discovered a new idol during a visit to the offices of *Theatre Arts* magazine when he happened upon a picture of the new superstar author Truman Capote. The erotically charged shot, by the photographer Harold Halma, had caused a mini-scandal when it appeared on the back of the dustjacket of Capote's debut novel, *Other Voices, Other Rooms*, in 1948. Standing in front of a blow-up of the provocative image, Warhol perhaps saw in the portrait of Capote – who was only four years his senior – an idealized image of himself: critically and commercially successful, of course, but also sexually confident. There was a slight physical

resemblance between the men, and Warhol now did his best to be mistaken for his new hero.

Warhol made blotted-line watercolour illustrations to accompany *Other Voices, Other Rooms* and started writing Capote fan letters, in which he offered to come and draw the writer in person. No reply materialized, so, growing bolder, he telephoned – and found himself in conversation with Capote's mother. Nina, an alcoholic, invited Warhol up to her Park Avenue apartment before adjourning with her new protégé to the Blarney Stone bar on Third Avenue.

Capote did not warm to Warhol's attentions – Nina eventually instructed him to leave her son alone – but the fixation bore fruit. Warhol sent his Capote illustrations to the art dealer Alexandre Iolas, who offered Warhol his first solo art show. *Fifteen Drawings Based on the Writings of Truman Capote* opened at the Hugo Gallery on 16 June 1952. There was little fanfare, and Capote and his mother failed to attend the opening. A short review in *Art Digest* noted, 'The work has an air of precocity, of carefully studied perversity,' and compared Warhol's drawings of boys, butterflies and cupids to the creations of Aubrey Beardsley and Jean Cocteau.

The exhibition could hardly be declared an unqualified triumph – no works were sold – but Warhol's campaign to conquer the fine-art world had been launched, and he had made a valuable contact in the shape of Iolas's assistant, David Mann. Moreover, both Iolas and Capote, a future friend (Andy would be a guest at the writer's Black and White Ball in 1966), would return to play notable roles in his later career.

Two months after Warhol's arrival in New York, in June 1949, *Time* magazine had anointed the art world's new house style when it asked of Jackson Pollock: 'Is he the greatest living painter in the United States?' The work of the Abstract Expressionists was characterized by a lack of recognizable subject matter and the idea that it represented

an unmediated transcription of the artist's inner state: 'Jack the Dripper' put his soul directly on canvas. Such an artistic culture was hardly a hospitable environment for Warhol, who in making both his commercial and personal work often began by tracing images from photographs and who, even as an illustrator, liked to introduce one or more mechanical steps between his hand and the final work – even at this early stage in his career, Warhol's essence was already consciously shaded from view.

While the Ab Ex crowd gathered at the Cedar Bar on MacDougal Street to trade stories and blows over drinks, Warhol found himself a home in New York's 'lavender' set. Joseph McCarthy and his Senate subcommittee might have picked out 'homosexuals and other sex perverts' as well as communists as 'national security threats', but there was nonetheless a flourishing underground gay art scene.

Photographer Otto Fenn's 58th Street studio served as a meeting place for gay men, especially those working in the fashion and commercial art worlds. In its open, anything-goes spirit, it could be described as a proto-Factory. Warhol got to know Fenn in around 1951 and made backdrops of vast, colourful butterflies for use in Fenn's photo shoots, not to mention drawings of the more informal goings-on at his studio, sketching men wearing jewellery and carrying purses.

Andy was not physically precocious: he was twenty-five years old when he had what appears to have been his first sexual encounter. He met Carl Willers at the New York Public Library, where Willers worked and Warhol went in search of source material for his illustrations. The two men's romance proved abortive. Decades later, Warhol would claim still to be a virgin; as mentioned before, Andy was a determinedly unreliable witness about his own life, but Willers confirmed that Warhol was so anxious about his appearance that he found physical intimacy difficult. What is not to be doubted is that he liked to watch others, finding the physical buffetings and couplings of people who were not

himself a fascinating spectacle. (He also liked to listen: it was in his early New York years that Warhol developed his very particular relationship with the telephone, talking to friends for hours on end, often late into the night since he feared falling asleep. Speaking on the telephone was Warhol's way of developing intimacy.) He would sketch friends having sex and made many studies of the male nude, including of Willers. His drawings of male genitalia were part of what he called his 'Cock Book'.

Warhol went to great lengths to combat his self-consciousness about his looks. He found his nose too bulbous so had it scraped at St Luke's Hospital and doctored photographs to make it look smaller; he also had his skin sanded. When his hair began to thin, he experimented with a peaked cap that he kept on even at dinner parties. Then, at Willers' suggestion, he started wearing a wig: initially light brown, but moving through blond to grey, white and silver. Dark glasses became a regular accessory behind which to take cover. In an attempt to combat his physical inferiority complex he also started frequenting the gym, becoming buff enough to complete several dozen push-ups.

Warhol began a long friendship with Charles Lisanby, a handsome television production designer who would go on to win three Emmys. The pair met at a party and ended the evening standing in front of a taxidermy store; Lisanby declared his admiration for a stuffed peacock in the store window. The following day, the bird was delivered to his home – a gift from Warhol, who would become his close friend. Lisanby was not attracted to him physically, however, and said that in his ill-fitting wig Warhol looked as though he had come from another planet.

In June 1956, the two men set off on a two-month trip to the Far East. Precisely what Warhol had expected to happen between them is unclear – no physical relationship ever developed – but he became upset when Lisanby brought a young man back to their room in Honolulu. They travelled on to Japan, Indonesia, Hong Kong, the Philippines, Bali, Calcutta, Cairo and Rome, where Lisanby got food poisoning

and Warhol stayed with him, sketching him awake and asleep, which Lisanby found disturbing. When they arrived back at the airport in New York, Warhol collected his bags and departed without a word; afterwards he told a friend he had 'gone around the world with a boy and not even received one kiss'. But despite Andy's disappointment, the pair remained friends. Lisanby also provided the title for one of the portfolio books Warhol circulated for promotional purposes, *25 Cats Name[d] Sam and One Blue Pussy.*

Warhol hankered after acceptance from the fine-art world. When Philip Pearlstein found increasing recognition as a 'serious' artist and became associated with the Tanager Gallery, a prestigious artists' cooperative with strong ties to the Abstract Expressionists, Warhol spotted an opportunity and leaned on his old roommate to promote his work there. One of the pieces Warhol wanted him to show featured 'boys kissing boys, with their tongues in each other's mouths', noted Pearlstein. It was not the sort of subject matter that was likely to find many champions among the macho Tanager set, and no progress was made, with the result that Pearlstein and Warhol's friendship cooled.

Warhol had more success when he took his portfolio to David Mann, who agreed to show his work in his new Bodley Gallery. This was far removed in spirit from the Abstract Expressionist scene but conveniently close to Serendipity 3, a chic ice-cream parlour-cum-boutique favoured by Warhol and frequented by socialites and fashion people. *Studies for a Boy Book*, which featured illustrations of penises decorated with bows, kisses and beautiful male faces (including Charles Lisanby's), opened on Valentine's Day 1956. Shortly afterwards, some of the less overtly erotic drawings were included in the *Recent Drawings* show at the Museum of Modern Art. On the cusp of a major breakthrough, Warhol offered to gift one of his drawings to MoMA's permanent collection. By way of response, he got a personal letter from the museum's legendary founding director, Alfred H. Barr – a rejection.

As mentioned, Warhol had a thing about shoes and feet. He made erotic sketches on the theme: a cigarette held between toes; feet with a pear positioned suggestively beneath their arches. His 'Foot Book' was hardly less explicit than his 'Cock Book'. The celebrated I. Miller ad campaign for women's fashion shoes in the *New York Times* had made him a commercial-art star, and he sold his *A la Recherche du Shoe Perdu* drawings (c. 1955), hand-coloured by friends at 'colouring parties' and bearing playful annotations ('Dial M for Shoe'), at Serendipity 3. Could he now parlay the theme into an art-world breakthrough?

The *Golden Slipper Show or Shoes Shoe in America* opened at the Bodley Gallery in December 1956. It featured drawings of fantastical boots and shoes decorated in gold paint and foil and designed to convey the personalities of Warhol's heroes: Mae West, Elvis Presley, Truman Capote (inevitably). The lettering, including Warhol's own signature, was provided by his mother, whose eccentric spelling rendered Elvis's surname as 'Presely'. *Life* magazine honoured the eye-catching blotted-line works with a double-page feature – but the caption undercut any triumph Warhol might have felt when it described him as a 'commercial artist' whose sketches of 'imaginary footwear ornamented with candy-box decorations' represented only 'a hobby'.

Progress was being made all the same. When Warhol arrived in New York he was twenty-one; by the time he turned thirty, in 1958, he had established himself as one of the most sought-after commercial illustrators in the city, winner of numerous awards and proud possessor of a very healthy bank balance. At the urging of his accountant, he set up Andy Warhol Enterprises and was affluent enough to invest in the stock market and to buy a four-storey townhouse at 1342 Lexington Avenue, which he decorated with an eccentric mixture of period furniture and penny-arcade machines. A panelled room at the rear was converted into his studio, and Nathan Gluck came a few times a week to work on commercial commissions. Not only did Warhol's mother

now have her own bedroom, she had her own basement apartment.

Just as promising for Warhol, the Abstract Expressionists' grip on the art world was on the wane, and Pop Art, a new movement from England that engaged directly with the consumer world, was waxing in its place. In New York, two artists would prove a bridge to the new style: Jasper Johns and his friend and lover Robert Rauschenberg.

In 1958, Johns's first solo show, at the prestigious Leo Castelli Gallery, had an electrifying effect: the young artist's flags and targets, said Castelli, were 'something one could not imagine, new and out of the blue'. Alfred Barr was moved to buy four works for the Museum of Modern Art, an unprecedented response to a show by such a young artist. Warhol was jealous – Johns was two years his junior, and Barr had recently turned down Andy's offer of a free drawing. He now began to hang around the Castelli Gallery, where Rauschenberg was also enjoying success. But when Warhol attempted to introduce himself to the pair, they turned away, and when his new show of fantasy recipes opened at David Mann's gallery in 1959 – *Wild Raspberries*, a play on the title of Ingmar Bergman's existential film *Wild Strawberries* – the *New York Times* declared it 'Clever frivolity *in excelsis*'.

Warhol needed fresh subject matter. As the new decade began, he turned away from decorative fripperies and fancies, and started to make paintings, many in black and white, based on cheap advertisements for canned food, wigs and nose jobs – there may have been a personal resonance there – as well as cartoon characters.

At this point, again through Tina Fredericks – *Glamour* was destined to provide his entrée to the world of glamour he had dreamed of since he was a boy – Warhol made an important new friend. This was Emile de Antonio, who was then operating as an artists' agent (or, to use his own preferred term, 'catalyst'). 'De', as he was known, would provide a conduit to the art world and represented, as Andy later said, his 'first big break'.

3

A Can of Soup and an Electric Chair

The obligation to spatter and drip had been holding Andy back. Happily, at the beginning of the 1960s, new contacts persuaded him to drop the idea that he could only make progress as a 'serious' artist if he painted like an Abstract Expressionist.

Emile de Antonio had become a frequent visitor to Warhol's studio-home on Lexington Avenue. One summer evening, he made his way in past the life-size statue of Punch and the Carmen Miranda-style platform shoe on the mantelpiece so that Andy could present him with two contrasting paintings of Coca-Cola bottles. 'One was just a pristine black-and-white Coke bottle,' he remembered. 'The other had a lot of abstract expressionist marks on it.' The latter, de Antonio told Andy, was 'a piece of shit', while the plain version was 'remarkable'. 'It's our society, it's who we are, it's absolutely beautiful and naked,' he summed up.

Around the same time, Warhol went to Leo Castelli's gallery – the de rigueur hangout for emerging artists – and for the first time laid eyes on a comic-strip painting by Roy Lichtenstein. He was delighted and told the gallerist's assistant, Ivan Karp, that he was working on similar pieces; would he like to come to see them in his studio? Karp thought Warhol, with his 'curious rough complexion and a shock of tousled hair', rather eccentric – *everyone* found Andy odd-looking – but agreed to pay a visit. As had happened with de Antonio, on arrival at his Lexington Avenue house, Warhol presented Karp with contrasting treatments of similar subjects: some 'tidy and sharp', others 'rendered with a great deal of expressive spattering'. Karp

asked Warhol about the latter. 'He explained that he didn't think he would receive recognition from the art world unless he spattered, because the dominant force in American art at that time was abstract expressionism.' Karp advised him to ditch the drips.

Karp started to bring collectors to see Warhol, securing him useful sales, although Andy had a disconcerting habit of donning ornate masks, of the kind worn at masked balls, to greet his guests, and of encouraging them to put on masks of their own. Soon Karp persuaded his boss, Leo Castelli, to pay a visit. The occasion was not a success, however, with the dignified Castelli finding both the artist and his work too peculiar. The paintings, he said, 'seemed to be spoofing all kinds of things. You really weren't quite sure what he was going to do.' The upshot was that Castelli decided he did not have space on his roster for Warhol – his manner was too similar to Lichtenstein's, he explained – and so Andy's ideal gallerist slipped through his grasp, although he politely purchased a couple of paintings.

Warhol did find a gallery of sorts for his new work. Throughout this period, he remained a successful commercial artist and window designer, and in April 1961 five of his newspaper-ad and comic-strip paintings – *Advertisement*, *Little King*, *Superman*, *Before and After* and *Saturday Popeye* – appeared as a backdrop behind the mannequins in the Bonwit Teller store window. But after his rejection by Castelli, Warhol knew that he needed to move away from what Lichtenstein was doing, and began to search in earnest for new subjects.

'The Pop artists did images that anybody walking down Broadway could recognize in a split second – comics, picnic tables, men's trousers, celebrities, show curtains, refrigerators, Coke bottles – all the great modern things that the Abstract Expressionists tried so hard not to notice at all,' he later reflected in *POPism*, his memoir of the 1960s. What would his signature image of the new decade be? In the 1950s it

had been ritzy shoes; what would replace them now? Finding himself stuck for ideas, he did what he would continue to do throughout the rest of his career: he asked other people for theirs, the more off-the-wall – 'nutty' was his preferred word – the better. The gallerist Muriel Latow provided the creative spark on this occasion, although she charged Warhol fifty dollars for her contribution. Her advice was simple: paint what you like most in the world. What were his favourite things? First, he was very fond of money; second, he really liked Campbell's soup.

'Many an afternoon at lunchtime Mom would open a can of Campbell's tomato soup for me, because that's all we could afford,' he would explain, remembering his childhood. 'I love it to this day.' So now he sent his mother to the local store to buy a can of each of the thirty-two varieties of Campbell's soup. Projecting images of the originals on to his canvas, he set about painting them precisely, with as few gestural flourishes and the colour as flat as possible, against a white background. The result was a series of iconic portraits of the humble consumer item. This was non-Abstract Expressionist subject matter treated in an entirely non-Ab Ex manner. It was also Warhol's eureka moment: his new friend Henry Geldzahler, a curator at the Metropolitan Museum, declared Andy's *Campbell's Soup Can* 'the *Nude Descending a Staircase* of pop art', compressing the whole cultural zeitgeist into a single, heroically banal image.

There were paintings of dollar bills too – shown singly, then in rows. Warhol refused to intellectualize his choices. 'I just paint things I always thought were beautiful, things you use every day and never think about,' he was quoted as saying in a somewhat mocking feature on Pop Art published in *Time* magazine in May 1962. 'I'm working on soup and I've been doing some paintings of money. I just do it because I like it.' (To prove how much he liked Campbell's soup, Andy was even photographed eating it from the tin in front of one of his paintings.)

Despite the fact that all the other rising Pop artists – Lichtenstein, Claes Oldenburg, James Rosenquist, Tom Wesselmann – were securing representation, Warhol still lacked a gallery in New York. As a result, his big Pop debut actually took place on the West Coast, at the Ferus Gallery in Los Angeles. The exhibition opened on 9 July 1962 and featured all thirty-two of the Campbell's soup can paintings uniformly suspended above a ledge that wrapped around the gallery. 'Cans sit on shelves,' Ferus director Irving Blum said by way of explanation of his display strategy. 'Why not?' Warhol was absent from the opening, and a neighbouring gallerist put actual Campbell's soup cans in his window: Warhol's paintings were $100 each, the cans a comparative bargain at three for 60 cents.

Just as the *Campbell's Soup Cans* show closed in August, news spread that Marilyn Monroe had committed suicide, and a new subject presented itself to Andy: one richly evocative of the world of Hollywood glamour and celebrity that had so entranced him as a child. This coincided with another breakthrough. At the suggestion of his assistant, Nathan Gluck, he had recently started experimenting with a stencil technique called silkscreen printing. This made it possible to transfer a photographic image directly on to canvas by means of a fine-print screen and to apply paint over it using a rubber squeegee.

Warhol's first silkscreen painting, *Baseball*, had been generated from an unidentified sports photo; he had also toyed with portraits of the actors Warren Beatty and Troy Donahue. Now he took a promotional photo of Marilyn Monroe from the 1953 film *Niagara* and began to experiment with different colour treatments. The order in which he worked was innovative: the background and facial details – lips, eyeshadow – were painted in first, before the black-and-white movie-still image was silkscreened over the top. The 'Flavour Marilyns' now began to emerge from Warhol's studio as if from a

factory production line. The serial repetitions were all essentially the same and yet were recognizably different thanks to the various palettes employed: *Orange Marilyn*, *Peach Marilyn*, *Cherry Marilyn*, *White Marilyn*. Further, the misregistrations between the black-and-white screened image and the hand-painted colour elements, not to mention the way the paint clogged in the screen, endowed each with what seemed a unique expressivity.

Variants included the *Marilyn Diptych*, which was powerfully suggestive not only of the film star's glamour but also of her, and everyone else's, mortality. With its grid of identical portraits, shown in colour on the left and in increasingly faded black and white on the right, it was also perhaps reminiscent of the iconostasis in St John Chrysostom Church in Pittsburgh that Warhol had spent thousands of hours staring at in his youth. There was an echo of Warhol's Byzantine Catholic upbringing in *Gold Marilyn Monroe* too. This featured a small, individual portrait of Monroe silkscreened on to an expansive gold field, the traditional religious symbol of an eternal other world, casting the *Some Like It Hot* star as a contemporary secular saint or Madonna.

Repetition now became central to Warhol's art. Many visitors to his studio observed that, as he worked, he would play the same song over and over – it was 'I Saw Linda Yesterday' by Dickey Lee on the day Ivan Karp first went to his Lexington Avenue home – until, as Andy himself explained, he 'understood what it meant'. He now seemed to be doing the same with images: his visual repetitions have a rhythmic effect, as in a pop song. A religious explanation has also been suggested for this aspect of Warhol's work: as the novelist Jeannette Winterson has observed, 'The rosary is repetition, the liturgy is repetition, the visual iconography of the Catholic Church depends on repetition.' Not that Andy talked about the church, invoking instead the emotionally numbing effect of such repetition.

'The more you look at the same exact thing, the more the meaning goes away, and the better and emptier you feel,' he said.

Silkscreening was a technique of cool objectivity that, in theory at least, removed all trace of the artist's hand – and all remaining trace of the Abstract Expressionist legacy – from Warhol's output. 'The reason why I'm painting this way is that I want to be a machine,' he told an interviewer in 1963, 'and I feel that whatever I do and do machine-like is what I want to do.' Impersonality, dehumanization of the process and 'an assembly-line effect' were the stated aims, the final work bearing no personal touch. If possible, Warhol wanted to remove himself from the work entirely. 'This way I don't have to work on my objects at all,' he explained. 'One of my assistants, or anyone else for that matter, can reproduce the design as well as I could.'

In part because of his manner of describing his working methods, as well as the so-called banality of some of his subject matter, passivity and indifference became key descriptors of Warhol's practice. However, the work was deeply expressive of both his skill – he had an inimitable colour sense – and preoccupations. There was both universality and autobiography in his choice of subject matter, especially his new female alter egos: Marilyn Monroe, Elizabeth Taylor and, following the assassination of her husband, Jackie Kennedy. In making icons of Taylor's personal drama of romance and rejection or in documenting Kennedy's brutally compressed passage from smiling First Lady-dom to grieving widowhood, Warhol was speaking of his own inner life and private turmoil.

Warhol's seemingly indifferent, machine-like method of making work now inspired the creation of a new persona, that of the 'glacial enigma'. His wigs were silver-blond, usually worn askew, while his expression was determinedly blank and his conversation increasingly mumbled and evasive. As the art historian John Richardson said: 'Nobody could ever "send him up." He had already done so himself.'

Warhol began making silkscreens of the images he had been working with earlier that summer – the Coke bottles, dollar bills and soup cans – completing a hundred in three months. Thanks to de Antonio, he also finally acquired a New York dealer: Eleanor Ward, owner of the Stable Gallery, who had helped Robert Rauschenberg early in his career – when he worked for her as a janitor – and who delighted in calling her new client 'my Andy Candy'.

A group show of New Realists and Pop artists that opened at the Sidney Janis Gallery on Halloween 1962 seemed to proclaim the overthrow of the Abstract Expressionists – Janis had been one of the movement's great supporters. Mark Rothko, Philip Guston, Robert Motherwell and Adolph Gottlieb all now quit the gallery in protest, while Willem de Kooning found himself turned away from an opening-night party. The Pop painter James Rosenquist remembered: 'at that moment I thought, something in the art world has definitely changed.'

That change was underlined when Warhol's debut show at the Stable opened a week later, on 6 November 1962. There was still a lot of personal hostility towards Andy in the New York art world – 'he was the most colossal creep I had ever seen in my life,' was one insider view – but the show made him a star. Alfred Barr bought a *Blue Marilyn*. However, when Warhol tried to gift a *Marilyn* to his old friend Charles Lisanby, the latter, no fan of Pop, refused the offer, causing Warhol to plead with him: 'Wrap it up in brown paper. Put it in the back of a closet. One day it'll be worth a million dollars.'

In early 1963, Warhol received his first portrait commission. The subject of the painting was to be the collector Ethel Scull, who, with her husband, Robert, had amassed a significant hoard of works by the Abstract Expressionists. On the day of the preparatory photo shoot, Warhol found Scull dressed in a designer outfit, evidently ready to be snapped by a high-fashion professional like

Richard Avedon as the basis for the silkscreen. Andy had other ideas, however, and whisked her off to a Photomatic machine on 42nd Street, entertaining her with jokes while she took hundreds of photo-booth portraits of herself. Afterwards he sifted and screenprinted selected images. The result was *Ethel Scull Thirty-Six Times*, an innovative grid of portraits showing his sitter in a variety of poses and moods. Destabilizing the idea of the subject's fixed personality, this was three dozen different Ethel Sculls. The portraits were delivered to the Sculls' home disassembled; Warhol was not present to put them in order himself, but sent word that his assistant could do it for him. 'It really doesn't matter,' he shrugged, practising his new glacial-impassive manner. The Sculls would auction off a significant portion of their Abstract Expressionist collection to pursue works by Andy and other Pop artists instead.

Warhol's burst of furious artistic production meant that his home was now overflowing with canvases. His mother had long been banished to the basement – with a steady supply of Cutty Sark scotch to keep her entertained, he joked – but the need for proper studio space led to him renting an old fire station nearby on East 87th Street. He needed an assistant for his art practice now, too: he was working on a large scale and required help with dragging the squeegee across the screen, not to mention with cleaning the screens.

In June 1963, Warhol attended a poetry reading in Greenwich Village and was introduced to Gerard Malanga, a twenty-year-old undergraduate poet from the Bronx who claimed some experience of the silkscreen process. Warhol hired him on the spot and set him to work the following day, at $1.25 an hour, then the minimum wage; his first task was to print some Elizabeth Taylor portraits. Andy was very taken with the curly-maned Malanga and invited him to meet his mother – an offer he had apparently never extended to Gluck, who remained his commercial-art assistant. Malanga would stay in

Warhol's employ until 1970. It was, as Malanga would say, 'a college job that lasted seven years', and would prove to be one of the most important collaborations of Warhol's career.

Warhol mounted no solo shows in New York in 1963 after his gallerist, Eleanor Ward, declined to display his new *Death and Disaster* images. The idea for this body of work came from Henry Geldzahler, his 'five-hours-a-day-on-the-phone-see-you-for-lunch-quick-turn-on-the-"Tonight-Show"' friend, as Warhol described him. (Andy remained very attached to his phone. Geldzahler remembered receiving midnight calls from him: 'he would say that he was scared of dying if he went to sleep.') Over lunch at Serendipity 3 one day, Geldzahler announced: 'It's enough affirmation of soup and Coke bottles. Maybe everything isn't always so fabulous in America. It's time for some death. This is what's really happening,' and handed him a copy of the *New York Mirror*. On its front page there was a photograph of a crashed aeroplane framed by the headline '129 Die in Jet'. The death theme was implicit in the *Marilyn* series, but Geldzahler's words would launch Warhol into an examination of darker subject matter and a new kind of realism, as well as a more radical, unapologetic use of photographic imagery.

The source images for the new *Death and Disaster* series were far removed from the essentially optimistic pop imagery of soup cans and glamorous portraits of Hollywood stars that had characterized Warhol's breakthrough works. The new silkscreen paintings used stark newspaper and police archive images of suicides, car crashes, atom-bomb mushroom clouds and the symbol of US justice, the electric chair. As a result, Warhol, the celebrant of the American way of life, suddenly shifted to charting the American way of death. The silkscreened treatments were deliberately harsh, with images blurred and presented in jarring colour schemes: *Vertical Orange Car Crash*, *Purple Jumping Man*, *Lavender Disaster*. Malanga said that each work

took no more than four minutes to make, but Warhol exercised great care in selecting the images: many were press-agency prints that had to be actively sought out, rather than the ubiquitous newspaper reproductions that might have fallen into his lap without effort.

In January 1964, the paintings went on display in Ileana Sonnabend's gallery in Paris. Aware that some thought his art did little more than unquestioningly promote consumerism and the American Dream (a theme of a symposium in 1962 at the Museum of Modern Art, which accused Pop Art of capitulating to capitalism), Warhol announced that the show would be called *Death in America*, a title that tentatively pointed towards a more serious critical engagement with his theme. The material was undoubtedly grittier in character – there was also his new *Race Riot* series, based on photographs showing a police dog tearing at the trousers of a black civil-rights activist in Alabama – but was Warhol trying to make a critical point or was he just attracted by the spectacular nature of the images? In short, was the Warhol of the *Death and Disaster* series politically woke?

In a radio conversation with Claes Oldenburg and Roy Lichtenstein, Warhol denied that he was attempting social comment. 'I'm not trying to criticize the United States... not trying to show up ugliness at all: I'm just a pure artist,' he said. Neither political commitment nor artistic purity was what suggested itself to Geldzahler when he thought about his friend's choice of imagery. 'I think that he's turned on by certain images, and those images that turn him on are loaded, supercharged images,' he would say. 'I think the death image, the image of corruption, the image of decay, is really closer to his heart.'

4

Factory People

Warhol had been an obsessive movie fan since developing his childhood pash for Shirley Temple, and had made another Hollywood star, Marilyn Monroe, the focus of his hit show at the Stable Gallery. So it was only logical that he would now start making movies – and (super)stars – of his own.

In spring 1963, Warhol bought a Bolex 8mm camera. He had fallen in with the New York underground film scene led by Jonas Mekas, founder of *Film Culture* magazine and the Film-Makers' Cooperative, and was keen to start shooting movies that could be shown alongside those of Jack Smith, Kenneth Anger and Stan Brakhage.

Although he cheerfully declared his own technical cluelessness, Warhol immediately started filming his first moving-image work – not that the image actually moved much in *Sleep*, an eight-hour study of a dormant male. Andy had spent a lot of time sketching Charles Lisanby as he slept on their Far East trip in 1956; now he used his Bolex tenderly to document the slumbering figure of his friend and lover John Giorno. 'He'd go into John's apartment maybe four nights a week, whatever,' recalled Malanga. 'And he kept shooting and shooting and shooting.'

The final version was projected at sixteen rather than twenty-four frames per second. Mekas, who championed Warhol's early film work, hailed the hypnotic effect of this reduced screening speed, saying it 'celebrated our existence by slowing down our perceptions'. Not everyone was quite so excited to be watching Giorno snoozing in

real time plus. When one audience member tried to escape, Mekas tied him to a chair to teach him a lesson – before watching, aghast, as Warhol himself walked out. 'Sometimes I like to be bored, and sometimes I don't,' Andy reflected on the incident in *POPism*.

At the same time, Warhol was preparing his second show for Irving Blum's Ferus Gallery in LA. Elvis Presley had already made an appearance in Andy's oeuvre in the form of a boot in his *Crazy Golden Slippers* show of 1956. For this new exhibition, Warhol worked – predictably, given his new fascination – with a still from the movie *Flaming Star* (1960) showing Elvis as a gun-toting cowboy. Instead of framed paintings, Warhol sent his West Coast gallery a box of stretchers and a roll of canvas with repeating six-foot Elvises silkscreened on a silver background. There were instructions for Blum to cut the images as he saw fit and to hang them edge to edge around the gallery walls.

This time, Warhol would not miss his own LA opening, so in September he, Malanga, the painter Wynn Chamberlain and the actor Taylor Mead – known as the 'first underground movie star' for his performance in Ron Rice's *The Flower Thief* (1960) – drove out to California for the show's opening. Since neither Malanga nor Warhol had a driving licence, Chamberlain and Taylor had to share the wheel. The road trip – the first time Andy had ever been west of Pennsylvania – was full of adventure, and provided the travellers with a Pop epiphany. 'The farther west we drove, the more Pop everything looked on the highways,' Warhol recalled in *POPism*. 'Suddenly *we all felt like insiders* because even though Pop was everywhere – that was the thing about it, most people still took it for granted, whereas we were dazzled by it – to us, it was the new Art. Once you "got" Pop, you could never see a sign the same way again. And once you thought Pop, you could never see America the same way again.'

The group stayed at the Beverly Hills Hotel and partied with

Dennis Hopper. Andy was dazzled by his new Hollywood friends and would underline the cinematic nature of the Elvis show by filming the installation using his Bolex camera; the already overlapping images almost seem to move as the camera pans around the gallery, zooming in on details. He also found time to shoot another film, *Tarzan and Jane Regained... Sort Of*, a spoof of Hollywood adventure movies. This featured Taylor Mead in the he-man role, working out on Venice Beach and taking a bath with his Jane, Naomi Levine, not to mention engaging in what has been described as a 'manhood contest' with a cameo-making Hopper.

If the trip intensified Warhol's commitment to film, it also set him thinking about the example of Marcel Duchamp. In the early decades of the century, Duchamp's career had represented a continual challenge to established notions of art; Warhol's was progressing along similar lines. Both had an interest in subverting the traditional divide between the rarefied realm of fine art and the utilitarian world of mass-manufactured objects: Duchamp had his *Readymades*, Warhol his soup cans. And both had removed the artist's hand as an essential ingredient in the creation of art. By coincidence, Duchamp's first ever US retrospective was due to open at the Pasadena Art Museum on 8 October 1963, so Warhol travelled over and enjoyed a long and sympathetic conversation with the godfather of conceptualism and his wife, Alexina. Several of Warhol's next career moves could be seen as Duchampian.

Back in New York, Warhol once again found himself in need of space: he was working faster and on a larger scale than ever before. So, in late 1963, he booked a truck and moved operations to a 100-by-50-foot former hat factory on the fifth floor of 231 East 47th Street. Located in midtown, close to Grand Central Station and just a block down the road from the United Nations, it was not in a typical artists' quarter. Nor would it be a typical artist's studio.

That was in large part thanks to Billy Linich, who had come to Warhol's attention while working as a waiter at Serendipity 3. A lighting designer with the Judson Church dance collective and host of happening-style 'Haircut Parties' (he was the son of a Poughkeepsie barber), Linich was a young man of many talents and a member of the San Remo Coffee Shop set in Greenwich Village. Warhol visited his apartment and was bowled over by the décor: the interior was swathed in silver foil and paint. Warhol now made up his mind that this would be the perfect look for his new studio too.

In the first months of 1964, Linich moved in and, armed with cans of silver spray paint and lengths of aluminium foil, gave the former hat factory a silvery makeover. 'It must have been the amphetamine but it was the perfect time to think silver,' Warhol remembered. 'Silver was the future, it was spacey – the astronauts… And silver was also the past – the Silver Screen… And maybe more than anything else, silver was narcissism – mirrors were backed with silver.' In a Duchampian spirit, the studio would be called the Factory.

Linich not only provided the decorative scheme, but he also brought his downtown friends, a cast of flamboyant characters with a shared love of speed, Maria Callas and histrionic comportment, whose continual presence ensured that the Factory would be the opposite of the traditional isolated artist's garret. Regulars included Freddie Herko, a dancer from the Judson Church collective, and the charismatic verbal magician Ondine (real name: Robert Olivo), as well as Rotten Rita, Silver George, Binghamton Birdie and the Sugar Plum Fairy. As Warhol said, he liked to keep 'open house', so when these 'strange characters would walk in and say, "Is Billy around?"' he would simply point them towards the back, where Linich had taken up residence. When they left, he would just wave them out with a 'See you tomorrow'. As a result, an alternative society began to spring up within the Factory's silvered walls.

Drugs were ubiquitous. The socialite Brigid Berlin, whose father was president of the Hearst Corporation, had been renamed Brigid Polk owing to her habit of giving anyone who wanted one a 'poke' (injection) of amphetamine through their pants. Not for nothing were the 'mole people', denizens of the Factory's underground world, also known as the 'amphetamine rapture group'. They became Warhol's travelling entourage too. One onlooker compared them to a crowd of locusts: 'They stripped everything – there certainly wasn't a pill of any kind left in the bathrooms.' Never a fan of illegal substances, Warhol sustained himself with a steady intake of speed, taken in a mild dose in the form of the prescription diet pill Obetrol. A quarter of a tablet a day was enough, he said, 'to give you that wired, happy go-go-go feeling in your stomach that made you want to work-work-work'. Warhol's astonishing early 1960s period of restless innovation and manic production was fuelled, John Giorno would suggest, by the twin circumstances of his arrival at artistic maturity and his discovery of Obetrol.

Armed with Warhol's old Honeywell Pentax 35mm camera, Linich – who would give himself the new identity of Billy Name – became the Factory's house photographer while Andy devoted himself to his Bolex. The mole people were not an inconvenience or obstruction to Warhol's work; on the contrary, their hyperactive creativity and emotional excesses became its primary ingredient and resource. 'I don't really feel all these people with me every day at the Factory are just hanging around me, I'm more hanging around them,' he said. Among other things, they would provide his cast of 'superstars' – Warhol's bohemian alternative to the Hollywood star system, onscreen surrogates and stand-ins for Andy himself – and perform in the films he was making.

Warhol and Malanga now set to work on a series of *Electric Chair* silkscreens, before tweaking the Factory's assembly line to start

spilling out sculptures rather than paintings. Warhol had decided that his next show at Eleanor Ward's Stable Gallery would consist of four hundred plywood sculptures of grocery boxes: Brillo pads, Kellogg's cornflakes, Campbell's tomato juice, Del Monte peach halves.

Silkscreening was still an important part of the process. Wooden boxes were ordered from a cabinetmaker in a variety of sizes and the graphics were then silkscreened on to them. Ward was unhappy; Warhol was becoming known as a painter, so the turn to sculpture seemed commercially perverse, as did the low prices for the works (in the region of $200–$400). The exhibition opened in April, with the facsimiles of humble consumer items arranged in the manner of a grocery-store stockroom. Barbara Rose, who would be a regular visitor to the Factory, hailed the works' 'stubborn unwillingness to look like art' and noted that Warhol had managed to 'invert Duchamp's art by virtue of context dogma', turning the gallery into a supermarket'. As Ward had feared, sales were poor – the Sculls cancelled their order – but that may have been what Warhol had hoped for. Witnessing his extraordinary artistic blossoming, Leo Castelli was now keen to add Andy to his artist roster; the commercial failure of the Stable show gave him an excuse to switch gallery.

The Stable Gallery exhibition also provided an excuse to throw a party at the Factory, an occasion that has been mythologized as 'the night the 60s began'. Loud rock music played as a unique mix of uptown and downtown types mingled in the silvery surroundings. Factory happenings would become must-attend events. Across the coming years, everyone would feel compelled to come and watch the goings-on on East 47th Street. 'There were political people, radicals, people in the arts, disaffected millionaires, collectors, hustlers, hookers. It became a giant theater,' said Emile de Antonio. Judy Garland and Allen Ginsberg, Liza Minnelli and Tennessee Williams, Michelangelo Antonioni and Salvador Dalí, Brian Jones and Mick

Jagger would all mount its stage. The Factory was a work of art in its own right: simultaneously a playground and an experimental society. It was also a site of forgiveness, a place where society's rejects and outcasts found acceptance and were even celebrated.

Warhol had not mentioned the Tarzan and Jane film project to his West Coast dealer, Irving Blum, while he was in Los Angeles. But when Blum came east a few months later to visit the Factory, Warhol led him into a viewing room where a projected image appeared on the screen. It featured two figures Blum quickly recognized: the artists Robert Indiana and Marisol. 'Their lips were touching. And there was absolutely no movement,' he remembered. At first he thought Warhol was simply projecting a film still, but then Indiana blinked. 'I was completely astonished by it,' Blum said. He was watching one of the *Kiss* shorts, where Warhol put two people in front of his camera, set the f-stop and instructed them to link lips while the Bolex ran through its hundred feet of celluloid (which equated to about three minutes, the longest take the Bolex could manage). Many *Kisses* were filmed, including some between men. The gay rights movement was gathering force, and the world of underground film seemed to grant Warhol greater licence than did the gallery world; Emile de Antonio had told Andy that his rejection by Rauschenberg and Johns, then a couple, was because he was 'too swish' and uncloseted. Warhol's cinematic works would feature much clearer, unambiguous depictions of gay life and themes than his paintings. Indeed, many of his films would premiere in gay porn theatres.

Warhol's early movies – such as the three *Haircut* films (1963), the idea for which came from Billy Name's Haircut Parties, and *My Hustler* (1965) – represent some of the most seductively homoerotic and even overtly gay works made in pre-Stonewall USA. The two *Mario Banana* films (1964) show Mario Montez, Warhol's first major drag superstar, eating a banana in a manner that did not seek to

suppress or deflect sexual analogies. *Couch* (1964) revolves around a series of sexual encounters that took place on an old red sofa, a piece of salvage furniture that played a prominent role in Factory life. Sexually explicit couplings, gay and straight, are shown, as are people taking naps and even doing a little motorcycle repair work. It is a work of extraordinary fixed-eye and sometimes-obstructed voyeurism: the camera never moves, even when onlookers come to stand between it and the action.

Other early films, shot in black and white and with no soundtrack, include the forty-five-minute *Eat* (1963), showing Robert Indiana consuming a mushroom, with a brief cameo from a cat, and the thirty-five-minute *Blow Job* (1963), where the camera is fixed on the face of an actor, DeVeren Bookwalter, while he is (apparently) fellated by a second, unseen figure; it culminates in Bookwalter lighting a post-climax cigarette. Warhol explained that these early silent films, with their unbroken focus on a single figure, represented the essence of traditional cinema's appeal: 'people usually just go to the movies to see only the star, to eat him up, so here at least is a chance to look only at the star for as long as you like.'

On the night of 24–25 July 1964, using an Auricon camera, which allowed for thirty-three-minute takes, Warhol shot his second long-form feature, *Empire*. Like *Sleep*, it was conceived to have a far greater running time than a standard movie; consisting of six and a half hours of celluloid and projected at sixteen frames per second, the screening length extended to over eight hours. In conventional movie terms, nothing actually 'happens', and the camera does not shift its gaze. There are no human actors; the building itself is the star. ('It's an eight-hour hard-on,' said Warhol.) The sun sets; lights on the Empire State Building come on; a beacon on the top of the Metropolitan Life Insurance Company Building flashes periodically. The point, explained Warhol, was simply 'to see time go by'.

There was a Duchampian inspiration for another important work of this period. When the architect Philip Johnson commissioned him to create a piece for the New York State Pavilion at the 1964 World's Fair, Warhol responded with a giant mural entitled *Thirteen Most Wanted Men*. Echoing Duchamp's *Wanted: $2,000 Reward* poster work of 1923, the portraits were drawn from mug shots given to Warhol by the policeman-boyfriend of Wynn Chamberlain. Mounted on the exterior of the pavilion, the mural was censored and painted over in silver, not because of the homoerotic suggestiveness of its celebration of 'gangster masculinity', but rather because it was feared that it might cause offence to Italian Americans by playing on mafia stereotypes.

This was disappointing for the artist, but the project spawned one of Warhol's most remarkable achievements. Around five hundred *Screen Tests*, or 'stillies' (still movies), as they were initially known, were shot between 1964 and 1966; 472 remain today. A corner of the Factory was reserved for their making, although the shoots themselves were spontaneous rather than prearranged, and insiders and visitors were called to sit before the Bolex lens as the mood dictated. As in a photo-booth shoot, the subject, centred and looking forward, was posed against a plain background. Warhol himself set up the shot, and then abandoned the camera to its work after instructing the sitter to remain as still and unblinking as possible while the Bolex ran through a reel of celluloid.

The result was a series of silent black-and-white close-ups lasting about three minutes, catching their subjects in a variety of states, from boredom through anguish to hilarity. The experience of sitting for them could be uncomfortable, and Malanga dubbed them 'studies in subtle sadism'. The whole of Factory life is here. The subjects represent a who's who of the mid-1960s avant-garde, ranging from real-world stars to the Factory's own designated superstars. Bob Dylan submitted to one and walked away with a *Double Elvis*, perhaps

43

as payment; Warhol was later upset to hear that Dylan was using the painting as a dartboard.

The Factory was a heightened, reordered version of the sublunary social world, so it was natural that many people left their everyday identities at the door. Renaming became something of a ritual, especially for the superstars who appeared in the lo-fi underground films shot there: Susan Hoffman became Viva, Susan Bottomly became International Velvet, Isabelle Collin Dufresne became Ultra Violet. The model and socialite Jane Holzer became Baby Jane Holzer (and was accorded the ironic title of 'Girl of the Year' by Tom Wolfe in an essay). Mary Woronov resisted when Warhol tried to rename her 'Mary Might' in reference to her six-foot Amazonian stature.

As his old boyishness and vulnerability increasingly gave way to a cool and sometimes cruel inscrutability, Warhol found himself rechristened too: Eleanor Ward's 'Andy Candy' now became 'Drella', a mixture of Dracula and Cinderella. 'I like candies,' Warhol in full Drella mode told *Vogue*. 'I also like blood.' His relationship with others could be vampiric, feeding on their ideas and feelings. And he could claim a genealogical connection to the Count: like Dracula, his own family came from the Carpathian Mountains.

The last months of 1964 brought both triumphs and losses. In October, Warhol participated in a group show at the Bianchini Gallery. *The American Supermarket* was a simulacrum of an ordinary grocery store with the twist that all the products were replicas made by artists – hand-painted wax pastrami and cheese by Mary Inman, turkeys by Roy Lichtenstein and Tom Wesselmann, and so on. Warhol's contributions included a print of his Campbell's soup cans as well as authentic tins of soup bearing his autograph and thereby transformed into works of art: Andy doing his 'Duchamp number', as he liked to call it. The critics were impressed, and all across Manhattan consumers could be seen with Warhol shopping bags.

The following month, on 21 November 1964, Warhol's first show at Castelli opened. *Flowers* was far removed in feel and subject matter from his preceding *Death and Disaster* series, and indeed from the kind of consumerist Pop work on show in *The American Supermarket*. It was once again Henry Geldzahler who had provided Warhol with his thematic cue when he showed him a floral photograph by Patricia Caulfield in *Modern Photography* magazine. Warhol had transformed the image through cropping, and his Day-Glo colour treatment seemed to make the four flowers (hibiscus blossoms, although critics who did not care for Warhol's effeminacy insisted on calling them pansies, while others assumed they were poppies, 'flowers of death') hover magically in front of the square-format canvases. The silkscreen paintings reminded some people of Matisse's cut-outs, while the critic Carter Ratcliff was dazzled by their 'flash of beauty that suddenly becomes tragic under the viewer's gaze'; the show was a sell-out. Quizzed about his recycling of 'second-hand' images, Warhol had protested: 'But why should I be original? Why can't I be non-original?' In the case of the *Flowers* paintings, one reason would become obvious: the risk of copyright infringement. Warhol ultimately had to pay Caulfield for the use of her source photography.

More important for Warhol in terms of his new ambitions was the *Film Culture* award he received in December for his contribution to movies. Jonas Mekas praised him for his 'cinema of happiness', which presented a 'new way of looking at things and the screen'. Warhol dodged the awards ceremony, although he did send an acknowledgement in the form of a silent film in which he and his entourage, a picture of collective ennui, passed around items from a basket of fruit. Experimentation continued on the Factory film production line, where Warhol turned to making talkies, or at least movies with synchronized sound. The first was *Harlot*, which was based on the life of Jean Harlow, aka the 'Blonde Bombshell', another

Hollywood star in the Marilyn Monroe hyperfeminine mould. Dressed in drag and a platinum-blonde wig, Mario Montez played the actress, and much of the action revolved around Montez-as-Harlow sitting next to her lesbian lover and (again) eating bananas in a sexually suggestive way, breaking off at one point to get up and kiss Gerard Malanga.

There was sulphur in the air at the Factory, where Andy's 'open house' philosophy meant that anyone was welcome to come in and act out their madness. One day, Dorothy Podber, later celebrated in her *New York Times* obituary as an 'artist and trickster', arrived brandishing a pistol and fired a bullet through a stack of *Marilyn* paintings. Warhol was horrified, but quickly grasped how to make the best of a bad situation: he sold the damaged works under new titles such as *Shot Light Blue Marilyn* and *Shot Orange Marilyn*.

There had been human casualties too, and there would be more. On 27 October 1964, Freddie Herko, one of the Factory's 'mole people' who had appeared in films such as *Kiss* and *Haircut*, high on LSD, danced naked out of a fifth-floor apartment window in Greenwich Village to the accompaniment of Mozart's *Coronation Mass*. Warhol's response was to say: 'Why didn't he tell me he was going to do it? Why didn't he tell me? We could have gone down there and filmed it!'

5

Edie and Lou

On 12 May 1965, Andy Warhol announced that he was now 'a retired artist'. According to the *New York Times*, 'the man who taught art how to pop and movies how not to move' had given up painting to devote himself to filmmaking. 'I've had an offer from Hollywood, you know, and I'm seriously thinking of accepting it,' the paper reported him as saying. The occasion for Warhol's Duchampian retirement gesture (Duchamp had swapped art for chess) was the opening of his *Flowers* show at Ileana Sonnabend's gallery in Paris. Peak Pop had been reached – it was even the theme of a striptease at the Crazy Horse Saloon – so it was the perfect moment for Andy to stop being a Pop artist.

The Paris trip was notable for another reason: among Warhol's travelling companions was Edie Sedgwick, the Factory's newest superstar. Andy's entourage had surprised the dancers at the nightclub Chez Castel by appearing with fifteen rabbits, and Sedgwick had caused a sensation with her outré outfit consisting of a black leotard and a white mink coat. 'It's all I have to wear,' she purred.

The pair had met only a few months before, at a party given by the producer Lester Persky, when Sedgwick's arm was in a cast following a car smash. Like so many of the Factory regulars, she was a troubled figure. 'I could see that she had more problems than anybody I'd ever met,' Warhol would say. Aged only twenty-two, she already had a history of mental illness and addiction, and her brother had recently committed suicide. But she was also magnetically attractive – everyone seemed to fall in love with her – and well born, and Andy found genealogical glamour irresistible. Possessed of a Mercedes and

a sizeable trust fund, which she would soon spend her way through, Edie hailed from a leading New England family, and Warhol loved that she could trace her lineage all the way back to the Pilgrims. 'Andy Warhol would like to have been a charming well-born debutante from Boston like Edie Sedgwick,' noted Truman Capote. Edie, meanwhile, was happy to take on the role of a Warholian alter ego, cutting her hair short and dyeing it silver to look like Andy's wig.

Sedgwick had quickly become Baby Jane Holzer's replacement as 'Girl of the Year' and started to appear in the talkies Warhol was now shooting. The title of *Poor Little Rich Girl* alluded both to the Shirley Temple film of 1936 that had had such an electrifying effect on Warhol as a child, and to Warhol's newest superstar's own status as a socialite and heiress. Shooting began in Edie's New York apartment; she is seen waking up, smoking cigarettes, applying make-up and having desultory conversations with her friend Chuck Wein. The first take was out of focus, so Warhol had to shoot a second, but the final edit takes advantage of the initial mistake and mixes footage from both. *Poor Little Rich Girl* premiered at the Film-Makers' Cooperative Cinemathèque in June 1965 in a double bill with another Factory film, *Vinyl*, an adaptation of Anthony Burgess's novel *A Clockwork Orange*.

Edie's distinguished family background allied with her distinctive fashion sense – dancer's black tights worn with a dime-store T-shirt or short fur coat, mini-dresses, outsize chandelier earrings, trademark eye make-up – attracted the attention of the mainstream media. In the August 1965 issue of *Vogue*, Sedgwick was hailed as a 'Youthquaker', a young influencer making a seismic impact on sixties society. In the *New York Post* in September, Nora Ephron profiled 'the girl that everybody is talking about'. Ephron acknowledged Edie and Andy as the new cultural scene's leading couple – 'In tandem, they span all the sets: jet, pop, show biz, Social

Register and any combination thereof' – but also made reference to the shadows in Sedgwick's biography, noting that she had been cut off by her parents and that her recent car accident had left her with a 'sinister scar' between her eyes. These shadows would only be magnified and lengthened by the blaze of attention Edie was now enjoying.

Warhol fan clubs had begun to spring up, and his first US retrospective was announced for early October at the Institute of Contemporary Art in Philadelphia. On the eve of the opening, Warhol and Sedgwick appeared on television on *The Merv Griffin Show*. 'No party in New York is considered a success unless they are there,' the host said as he introduced these 'two leading exponents of the new scene'. What happened next was very Warholian. 'I must warn you, Andy won't say a word,' Sedgwick told Griffin as she sat down. For the next twenty agonizing minutes, Andy did his best not to speak, instead smiling, chewing gum, occasionally whispering something into Sedgwick's ear and, when pressed by the host to talk, limiting himself to a barely audible 'yes' or 'no'. Meanwhile, Sedgwick cheerily fielded questions about their moviemaking, including her status as a superstar, which she explained was 'something either fantastic or ridiculous, and that remains to be seen'. Privately, she was increasingly convinced that it would turn out to be something ridiculous.

Warhol enjoyed being ventriloquized. In public, he was adopting an increasingly anti-personal approach to personal communication that was the equivalent of his wish to remove himself from the making of his art. He was quick to raise the shield provided by inexpressive exclamations such as 'gee', 'uh' and 'really', delighting in the role of 'monosyllabic oddity' and Keatonesque idiot savant, playing dumb to his media interrogators. Claiming to be blank and without essence, if substance was

required he insisted on being fed his lines by others. Asked by another television interviewer for insight into his art and opinions, he responded: 'I'm so empty today. I have a cold and, uh, can't think of anything. It would be so nice if you told me a sentence and I just could repeat it.' It might seem very passive, but it proved a highly creative and successful strategy.

An interview with Gretchen Berg in 1966 would contain many definitive Warholisms, including the famous declaration: 'If you want to know all about Andy Warhol, just look at the surface: of my paintings and films and me, and there I am. There's nothing behind it.' But a comparison of the verbatim transcript of the interview with the final printed text has shown that Warhol never said those words, or even anything much like them. Berg made them up for him, and Warhol accepted them gratefully and adopted them into his new persona. Vampire indeed.

A huge crowd was expected for the public opening of Warhol's first retrospective in Philadelphia, so the curator Sam Green removed the art from the walls to keep it safe. Andy was tickled by the idea of an art event with no art. Several thousand people, mostly students, gathered and chanted, 'We want Andy and Edie'; chaotic scenes greeted the star couple's arrival and they quickly became trapped on a staircase, where they stood to autograph objects – shopping bags, train tickets, soup cans, Edie taking his mother's role and often signing Andy's name for him – before making their escape on to the roof, down a fire escape and into police cars on standby. 'It was as if Mick Jagger had been stuck on the subway and discovered by teenage girls,' Green described the scene. The comparison was just. Warhol was like a rock star. As he remembered: 'we weren't just *at* the art exhibit – we *were* the art exhibit.' And he was delighted: he now had the fame he had always hankered after. There was little he enjoyed more than signing autographs.

Warhol thought about renaming the Factory 'Hollywood', and Edie perhaps represented his best path to the real Hollywood. But there was trouble in paradise. From the beginning, there had been a sadistic quality about Andy's filmic examinations of his blue-blooded superstar. *Kitchen* (1965), featuring Sedgwick and Roger Trudeau as an unhappy couple, ended with Edie being strangled, while in *Beauty No. 2*, made around the same time, an off-screen figure, a voyeur in the dark, baited her with hostile questions about her family, until she threw an ashtray at her unseen tormentor.

The effects of Warhol's psychological cruelty were undoubtedly aggravated by the copious quantities of drugs Edie was taking. But she was also legitimately aggrieved about the lack of financial reward. When she complained about not being paid for her work, Andy reasoned that he was making no money from the films – which was true: he had earned a lot more as a commercial artist in the preceding decade, and was selling his artworks to finance his films now. Their relationship seems to have suffered after members of Bob Dylan's entourage began to take an interest in the Youthquaking sensation. There would be acrimony between the two artists' camps; Warhol is rumoured to be one of the characters, perhaps 'Napoleon in rags' or the 'diplomat on the chrome horse', referred to in Dylan's 'Like a Rolling Stone'. 'I hear he feels you destroyed Edie,' Warhol reported being told in *POPism*.

Edie wanted to make a film about the Hollywood actress-singer Lupe Vélez, who committed suicide in 1944. Legend held that the 'Mexican Spitfire', as Vélez was known, was found dead with her head in a toilet bowl. In some respects, *Lupe*, shot in December 1965, would be a continuation of *Poor Little Rich Girl*; Warhol may even have intended it as a portrait of his superstar's own struggles. The film showed Edie, making no pretence to 'be' Vélez, putting on her make-up, playing with a kitten and getting a haircut from Billy

Name, occasionally cutting to shots of her slouched over a toilet. Warhol was growing frustrated by his superstar's shifts in attitude. 'Edie would still vacillate between enjoying the camp of making movies with us and worrying about her image,' he recalled; '...It was a little insane.' At Andy's request, the playwright Robert Heide had worked on a screenplay for the project and recounted Warhol asking him where Freddie Herko had killed himself before adding: 'Do you think Edie will let us film her when she commits suicide?'

Warhol was developing fresh interests. For instance, there was Ingrid Superstar, whose real name may have been Ingrid (or Irma) von Schefflin (or von Scheven), and who may have been adopted because of her resemblance to Sedgwick; solid facts are hard to come by in this particular Warhol superstar's case. According to one Warhol regular, Rene Ricard, she was discovered in a 42nd Street bar and was dubbed the 'Ugly Edie'. She would be cast as Jackie in Warhol's film about the Kennedy assassination, *Since* (1966), in which Ondine played Lyndon Johnson, the role of JFK was taken by Mary Woronov and Gerard Malanga was cast as the President's assassin, shooting him with a banana.

In the same month that he filmed *Lupe*, Warhol began his association with the Velvet Underground. He liked their confrontational approach – their raw, avant-garde sound, their graphic lyrics about drug use and S&M – and took an immediate shine to their leader, Lou Reed. Keen to expand his entrepreneurial activities, Warhol decided he would be the band's manager. One of the first innovations he suggested was that they should perform some of their songs with a German singer and actress called Nico. Reed was not entirely won over, but the Velvet Underground became the Factory's house band, and Nico became Andy's newest superstar. Warhol liked how different she was from his previous superstars: 'Baby Jane and Edie were both outgoing, American, social, bright,

excited, chatty – whereas Nico was weird and untalkative,' he explained. The fact that people used words like 'memento mori' and 'macabre' (as well as 'Norse goddess') to describe her only made her more attractive to him.

Inevitably, Warhol would film the band in a jam session at the Factory with their new recruit. Nico bangs a maraca on a tambourine, while her son, Ari, plays at her feet and John Cale saws at his viola. The improvised rehearsal comes to a premature end when the police turn up to investigate a noise complaint.

Warhol also planned to put the band at the centre of a ground-breaking new mixed-media performance. 'Since I don't really believe in painting anymore, I thought it would be a nice way of combining… music and art and film all together,' he explained of the multisensory spectacular that would become known as the Exploding Plastic Inevitable. The Velvet Underground would play while Warhol's movies were projected behind them, strobes raked the audience and stage, and Malanga led a troupe of interpretive dancers.

In April 1966, the Exploding Plastic Inevitable took up residence at the Dom, a former Polish meeting hall on St Mark's Place. An ad – 'Come blow your mind' – appeared in the *Village Voice* to promote the series of performances. A critic from the same paper said the sound was like 'the product of a secret marriage between Bob Dylan and the Marquis de Sade'. It obviously looked like the future: an image of the Exploding Plastic Inevitable found its way into Marshall McLuhan's playful handbook to the coming global village, *The Medium Is the Massage*. Ondine and Brigid Berlin ran up and down the aisle, giving real injections of amphetamine to audience members as on stage Malanga did a whip dance and pretended to inject heroin with a ballpoint pen, and Warhol conducted what Mekas described as 'light symphonies of tremendous emotional and mental pitch'. Members of the band had to wear dark shades

on stage, 'not through trying to be cool but because the light-show could be blinding at times,' explained guitarist Sterling Morrison.

The Dom run coincided with the opening of Warhol's new exhibition at Leo Castelli Gallery, his first in more than a year. Andy insisted he was out of ideas, so he asked Ivan Karp to propose a theme. Something 'pastoral, like cows', came the suitably 'nutty' suggestion, so Warhol covered the walls of one room of the gallery with wallpaper featuring a repeated image of a fluorescent pink cow's head on a yellow background; in the other he placed helium-filled silver Mylar pillows, which Warhol referred to as 'floating paintings' and 'silver clouds' and which symbolized his freedom: 'I felt my art career floating away out of the window, as if the paintings were just leaving the wall and floating away,' he recalled in *POPism*. The result was one of the most memorable happenings in 1960s New York, and a fitting way for Warhol to say farewell to art. As Bob Colacello would later observe: 'The man who had wanted to be Matisse now wanted to be Louis B. Mayer.'

Not only was Warhol a filmmaker and studio head now, he was also a record producer. Or that, at least, was his nominal role on the album *The Velvet Underground and Nico*, which the band began recording in New York. As well as helping to secure a contract with MGM's Verve Records, Warhol designed the album's cover, which featured a yellow banana sticker with an instruction at its tip to 'Peel slowly and see'. Those who did would discover a peeled pink banana underneath – bananas and their metaphorical possibilities were big in Andy's world in these years.

In September 1966, Warhol scored a surprise movie hit with an unwieldy twelve-reeler shot in large part in the famed bohemian shelter the Chelsea Hotel. Six and a half hours long, it was an impossible proposition for theatrical distributors, so Warhol and his increasingly influential film collaborator, Paul Morrissey, devised

a means of putting two reels on screen simultaneously, side by side; one in black and white, the other in colour, one silent, the other with sound. Although Ronald Tavel wrote a screenplay for a few scenes, *The Chelsea Girls* was a largely unscripted and highly intimate portrait of the lives of the Factory's superstars: Brigid Berlin was seen shooting up through her jeans, Nico wept, while, in the most famous sequence, Ondine flew into a rage and slapped Ronna Page when she called him a phony. A scene was filmed with Edie Sedgwick, but was omitted from the final film as she now claimed to be under contract to Dylan's manager, Albert Grossman.

Emile de Antonio compared Warhol's methods in these years to those of the Marquis de Sade: 'He was able to get a lot of people to do weird things in his early films who wouldn't have done it for money or D.W. Griffith or anybody else.' In her memoir of life at the Factory, *Swimming Underground*, Mary Woronov wrote of a ghoulish, aggressive 'black dog that lived in my stomach' and the way that it was invited out to perform in Warhol's films: 'it was the people at the Factory who coaxed the unwanted stray out of my shadow and encouraged her to play in movie after movie.' Warhol, assisted by Morrissey, provoked emotional intrigue among the superstars, playing them off against one another and delighting in capturing the results on film.

The Chelsea Girls, with music by the Velvet Underground, was hailed in *Newsweek* as 'the *Iliad* of the underground' as it passed from the Cinemathèque into commercial theatres. Not everyone was impressed. Brigid Berlin's mother sneaked in to see it with a friend and expressed her displeasure to her daughter afterwards, while film critic Rex Reed would call it 'a three-and-a-half-hour cesspool of vulgarity and talentless confusion'. Bosley Crowther in the *New York Times* announced: 'It has come time to wag a warning finger at Andy Warhol and his underground friends and tell them,

politely but firmly, that they are pushing a reckless thing too far.' *The Chelsea Girls* certainly presented a troubling vision of life among Warhol's entourage.

After the Dom residency, the Exploding Plastic Inevitable caravanserai had moved on to LA for a month-long residency at the Trip club. It lasted three nights. Local music legend Cher quipped that the Exploding Plastic Inevitable would 'replace nothing, except maybe suicide'. Woronov, who was part of the touring troupe, explained what she called the West Coast–East Coast 'dichotomy': 'they took acid and were going towards enlightenment; we took amphetamines and were going towards death.'

Just as bad, the release of *The Velvet Underground and Nico* was delayed, seemingly through lack of record company enthusiasm. The album finally emerged in March 1967, but was quickly withdrawn when the actor Eric Emerson complained that a stage shot of the group on the back of the sleeve showed them performing in front of a projected image from *The Chelsea Girls* in which he appeared. His permission had not been sought, so he now demanded $500,000. Unsurprisingly, MGM did not want to pay. The album would be relaunched three months later, in June, against the Beatles' *Sgt. Pepper's Lonely Hearts Club Band*. With its speeding rhythms, lyrical injunctions to 'Taste the whip' and declaration that heroin is 'my wife and my life', *The Velvet Underground and Nico* was out of step with the prevailing mood of the Summer of Love. The hippies in Haight-Ashbury were never going to dig it.

When Warhol next saw Lou Reed, they quarrelled and Nico was prevented from going on stage with the band. In a subsequent phone conversation, Andy called Lou a 'rat' and Reed announced to the press: 'I fired Warhol!' Andy's career as a rock impresario was over.

6

Rebirth

The opening months of 1968 were full of enforced endings and new beginnings for the Factory crowd. They were also full of troubling portents.

The building at 231 East 47th Street was due to be knocked down to make way for an apartment block, so in February 1968 Warhol moved operations to 33 Union Square West. The timing was fortuitous, as things were unravelling badly at the Silver Factory.

Many thought Warhol had grown drunk on his own power. 'It was like Louis XIV getting up in the morning,' Henry Geldzahler commented. 'The big question was whom he would pay attention to that day.' No wonder many developed ambivalent feelings towards manipulative King Andy, who was so good at manipulating the feelings of his subjects.

The superstars were, in Warhol's own words, the 'leftovers of show business': gifted people leading marginalized existences. They did not act roles in the films so much as perform heightened versions of themselves. 'The lighting and sound are bad, but the people are *greeeeaaaat!*' Andy would say. But a lot of them felt let down and exploited by Warhol, in whom they placed probably unreasonable hopes of genuine (and not just Factory-made) superstardom. This was actually the subject of the final film he made with Edie Sedgwick, in November 1966. *The Andy Warhol Story* is one of the strangest films he shot. In it, Warhol, played by Rene Ricard, invites the Sedgwick character to his apartment, where the conversation quickly turns to the way he manipulates and then disposes of people. It was rare for

(the real) Warhol to make an appearance in front of the camera in his own films, but here he comes into frame as he attempts to give Ricard direction, urging the improvising actors to greater heights in discussing his faults.

'Even I knew this was not the way to Hollywood,' wrote Mary Woronov in her memoir *Swimming Underground.* 'I was not really sure what this was the way to, other than an odd kind of boredom… Of course there were endless amounts of drugs too, which sort of made up for it.' Boredom and drugs and dashed hopes combined to make the behaviour of the already unstable Factory denizens even more erratic. Infighting increased, and a heavy psychic price was being exacted. Some complained that Warhol did not do enough to save the victims – his advice was simply 'Do everything'. When his former lover and lighting designer Danny Williams – who reportedly pulled Andy's wig off at dinner one day – committed suicide in July 1966, Warhol refused to speak to the dead man's mother.

The sense of paranoia and siege within the Silver Factory had become overpowering. In December 1967, Random House published *Andy Warhol's Index (Book)*, which documented life at the Factory in black-and-white photographs. A burst of colour was provided by a pop-up medieval castle that showed Warhol and others at the windows. 'We're attacked constantly!' read the caption. And there were no defences against the attacks: Andy was still keeping open house.

Guns had become all too familiar a presence after Dorothy Podber had put a bullet through the brow of a stack of silkscreened *Marilyn*s. Recently, a character known as Sammy the Italian, friend to Ondine, had played a not particularly entertaining game of Russian roulette with the staff. Then there was Valerie Solanas, a feminist with radical views and the founder of SCUM, aka the Society for Cutting Up Men (membership: one). She had brought Warhol a script entitled *Up Your Ass*, which even Andy found too outrageous to produce. When she

asked for the script back, he said he had lost it and offered her a part in his new movie, *I, a Man*; she was given the role of 'Girl on the Staircase' and paid $25 for her trouble. Perhaps, as he was with other Factory superstars, Warhol was guilty of placating her with promises that he could make her famous. Whatever the case, she now became convinced that he was trying to steal her work, and turned against him. 'Talking to him is like talking to a chair,' Solanas told the French publisher Maurice Girodias (who she decided was also trying to steal her work). Unbeknown to Warhol, she too had become interested in guns.

Firearms were on display during the shoot of *Lonesome Cowboys* in Tucson, Arizona, in January 1968, and not all of them were just for the cameras. Warhol's own entourage included a gun-wielding car thief who went by the name of Vera Cruise, while the local sheriff was a regular visitor to the set, especially after the filming of a disturbing scene in which Viva is stripped naked in the midst of a gaggle of excitable cowboys, who busy themselves tormenting her and humping one another. Warhol would be put under FBI surveillance as a result.

Lonesome Cowboys was a satire on Westerns that continued the move towards more conventional moviemaking methods, although a scene featuring Joe Dallesandro being shown ballet exercises by a fellow cowboy to build up 'the buns' suggests that Warhol was keen to maintain an ironic distance from Hollywood. The script of Warhol's 'Pornographic Western' was written by Paul Morrissey, who was no avant-gardist and numbered John Wayne among his favourite actors. Viva, Warhol's new female alter ego, who had already appeared in several Factory features including *Tub Girls* and *Nude Restaurant* (both 1967), played the role of Ramona – an initial influence from *Romeo and Juliet* was claimed, although Warhol admitted this was lost sight of once the actors started improvising – who is harassed by local cowboys; like Sedgwick, she would complain at not being properly remunerated.

The idea of filming in Tucson was born when Warhol, Viva and Morrissey had visited the University of Arizona the previous autumn as part of a cross-country college lecture tour organized by the American Program Bureau. Warhol had enjoyed the experience, although Viva was less than positive in her assessment of their audiences: 'They really hated all of us, but they especially hated Andy. They were always hostile.' The presentations had consisted of a screening, followed by a speech by Morrissey and a Q&A with Viva. Warhol stood silently aloof, in leather jacket and dark glasses. But was that really Warhol behind the shades? It was a question now being asked by the University of Utah, which had decided to withhold Andy's $1,000 speaking fee on the grounds that he had sent a lookalike in his place. And it was true. Allen Midgette, a Factory regular who appeared in *Lonesome Cowboys*, had bleached his hair, put on dark glasses and impersonated Warhol – not very convincingly. To compensate, Andy agreed to give further lectures, where he was heckled and detained by the authorities while identity checks were carried out.

Back in New York, it was Morrissey who chose the new Factory space, against Billy Name's wishes. A Catholic with conservative political views and a strong anti-drug attitude, Morrissey had grown tired of the mole people's speed-fuelled antics, not to mention the old Factory building's ubiquitous silver spray. 'It was hideous. There was silver powder in your hair and lungs and you couldn't ever get clean,' he complained. Visitors now stepped out of the elevator into a formal front office, where they were greeted by the sober pair of Morrissey and another recent recruit, Fred Hughes.

Hughes was a smart, suave twenty-something Texan who, like Warhol, was not averse to romancing his humble background – he claimed that Howard Hughes was a relation. (Like Andy, he was also a Catholic; Warhol's mother, Julia, called him 'the Priest'.) His

life had been transformed in his college years when the wealthy collectors Jean and Dominique de Menil befriended him while he was studying art history in Houston. His and Warhol's paths first crossed at a Merce Cunningham benefit given by Philip Johnson in 1967. 'I never questioned whether we'd get along or not,' Hughes later recalled. 'For one thing, he knew who I was, and he saw the pot of gold at the end of the rainbow, just like I did.' And it was true: Hughes was a familiar figure at Leo Castelli's gallery, and would prove a much better salesperson for Warhol than Castelli had been. The price for a portrait commission – an activity in which Andy would now specialize – was quickly set at $25,000, and Hughes applied himself to bringing in clients. 'What I did is *do*,' he said.

Jed Johnson, a well-spoken, elegantly dressed young man from Sacramento who looked as if he had stepped out of a fashion billboard, was another new addition to the team; he would be Warhol's domestic partner for many years. Billy Name was still around, although he was an increasingly spectral presence after he moved into the darkroom at the back of the screening room.

The Factory would no longer be a site for cultural revolution; it was a place of business. Socializing was increasingly done elsewhere. A while before, Warhol and his entourage had started hanging out at Max's Kansas City, a popular nightspot for artists, writers and musicians. Robert Rauschenberg, William Burroughs and Allen Ginsberg were regular visitors; the Velvet Underground would play a residency and record a live album in the venue. Warhol and his friends now began to dominate the back room. Valerie Solanas went there too, although she sat apart from the Factory crowd.

In February 1968, as the second Factory was being installed, Warhol flew to Stockholm with Viva for the opening of his first major European retrospective. The façade of the Moderna Museet had been plastered with the *Cow Wallpaper* that had covered the walls

of the Leo Castelli Gallery two years before. Inside, the presentation, overseen by the pioneering curator Pontus Hultén, was built on the idea of repetition: few motifs but many individual works. Alongside the *Marilyns*, *Electric Chairs*, *Brillo Boxes* and helium-filled balloons were screens showing looped extracts of the likes of *Sleep* and *Empire*, the integrated layout emphasizing these early Factory films' 'stillie' status as (barely) moving paintings. The pronouncement for which Warhol is perhaps most famous – 'In the future, everyone will be world famous for fifteen minutes' – made its first appearance in print in the accompanying catalogue. However, as with so many of his most-cited sayings, it is not clear that it was actually Andy who originated the phrase; the artist Larry Rivers, photographer Nat Finkelstein and even Hultén are possible alternative sources.

The show was a summary of Warhol's career to date and would mark a turning point. The exhibition posters eschewed the traditional practice of using an image and instead simply carried citations from the catalogue, elegantly and unfussily set by the designer John Melin. The 'In the future' quote proved popular and helped to carry Warhol's (or someone else's) words across the globe, all the more fervently after word spread on 3 June that he had been shot.

* * *

'He had too much control of my life.' Valerie Solanas made her dramatic announcement as she handed herself and her guns – a .32 automatic and a .22 revolver – over to William Schmalix, a rookie cop on traffic duty in Times Square. It was eight o'clock on the evening of 3 June 1968. At that moment, Solanas's victim was undergoing surgery in Columbus Hospital. Emerging from the operating theatre after being resuscitated by Dr Giuseppe Rossi, Warhol was now assessed as having a fifty-fifty chance of survival.

When the news reached them, the Factory superstars began to gather in the Columbus Hospital waiting room. Viva told reporters about the shooting as she had witnessed it down the telephone line from the hairdresser: 'I heard five shots and a lot of screaming. I heard Andy screaming. I thought it was a joke, then the phone was dropped.' Taking up a line from *Andy Warhol's Index (Book)*, Ingrid Superstar said: 'Andy's shooting was definitely a blow against the cultural revolution. We're constantly being attacked.' Late that night, Julia Warhola arrived in her familiar babushka's headscarf; she prayed that her Andek would be saved so that he could marry Viva. Andy's brothers, John and Paul, appeared too. Elsewhere, Solanas was making her own statement. 'There are many involved reasons,' she told police of her motives. 'I have written a manifesto of what I am and what I stand for.' The story made the headlines; Solanas had secured her fifteen minutes of fame. But the shooting of the politician Robert Kennedy the very next day would quickly trump her failed attempt on an artist's life.

Warhol had suffered terrible internal damage. As a newspaper report had it, the bullet 'twisted crazily through his abdomen and chest' and hit his right lung, oesophagus, gallbladder, liver, spleen and intestines before exiting through his back. It was 'a horrible, horrible pain, as if a firecracker had exploded inside me,' Warhol said later. 'It hurt so much I wished I was dead.'

Solanas appeared in the Manhattan Criminal Court, where she shouted: 'I was right in what I did! I have nothing to regret!' Some people agreed. A feminist group calling themselves Up Against the Wall Motherfucker praised Solanas as a 'chick with balls'; Warhol, by contrast, was a 'plastic fascist'. *Time* magazine published an article, 'Felled by SCUM', that seemed to suggest Warhol had got his comeuppance. 'The pop art king was the blond guru of a nightmare world, photographing depravity and calling it truth,' it commented.

When he could speak again, Warhol decried not having filmed Solanas's assassination attempt. 'If only she had done it while the camera was on!' he said.

As he lay convalescing in his hospital bed, Warhol's thoughts turned to work and he discussed a new film project with Paul Morrissey. The idea for *Flesh* was inspired by another film that was then in production, *Midnight Cowboy* by John Schlesinger, which would go on to win three Oscars. Schlesinger had asked to shoot a party scene for it at the Factory, with Warhol slated to appear as himself. Andy had declined the latter offer and, thinking Schlesinger and the mainstream were stealing his thunder – the central character, played by Jon Voight, was a male hustler – set out to create a rival feature.

Flesh would be the first in the so-called 'Paul Morrissey Trilogy'; it would see him taking increasing control of the Factory's film projects, and would feature superstar Joe Dallesandro in the lead role, playing a man tasked by his wife to turn tricks to pay for her girlfriend's abortion. Dallesandro would return in the other films in the Trilogy – *Trash* and *Heat* – and become an icon of the early 1970s sexual and cultural revolution, even appearing on the cover of *Rolling Stone*. 'His physique is so magnificently shaped that men as well as women become disconnected at the sight of him,' the *New York Times* film critic Vincent Canby would write. *Flesh* also saw the screen debut of two new Factory superstars: Candy Darling and Jackie Curtis.

Warhol had recovered sufficiently to leave hospital in time to spend his fortieth birthday in his own bed on Lexington Avenue. It would be another month before he started going out in public again: ever the voyeur, his first post-release walk carried him to a peep show and to restock 'on dirty magazines'. His first night out came on 4 September, when he attended the wrap party for *Midnight*

Cowboy, which featured many Factory regulars in its climactic scene. He also did an interview with the *Village Voice* writer Leticia Kent. 'I'm so scarred I look like a Dior dress. It's sort of awful, looking into the mirror and seeing all the scars,' he told her. Warhol took Polaroids of his wounds, and raised his polo-neck shirt so that Richard Avedon, known for his fashion work, could photograph the distinctive pattern of stitches and scars on his torso. The following year he would sit, his hands clasped and eyes closed, and the medical corset he now had to wear exposed, as Alice Neel painted him. The result was a strikingly intimate portrait of a meditative ascetic: St Andy of the Scars.

If Solanas's failed assassination attempt was bad for Warhol's physical and mental state, it was good for business. The prices of his works rose, and the publicity the incident generated helped to make *Flesh* a commercial success: it ran in one cinema for seven months. By the time the Morrissey-directed movie opened at the New Andy Warhol Garrick Theater, Warhol was ready to shoot his next film, which he would helm personally this time. Called *Blue Movie*, it starred Viva and Louis Waldon as lovers meeting for a last time in a borrowed apartment. They prepare food, take a shower and discuss the Vietnam War – Warhol actually claimed that the film was 'about' Vietnam and possible political responses to the situation there – and engage in unsimulated sex.

Released in 1969, *Blue Movie* is regarded as having heralded the beginning of the 'Golden Age of Porn', when for the first time sexually explicit films played in ordinary cinemas and attracted mainstream audiences. Warhol initially wanted to call his erotic feature *Fuck*; when he had made a film showing someone sleeping he had called it *Sleep*, he reasoned, so why should his film showing a couple fucking not be titled with similar plainness of intent?

Warhol's favoured title for his first novel was *Cock*. In the event,

it was now published as *a*. Purporting to document a single day in the life of Ondine, the material was actually gathered episodically in the form of tape recordings across a period of two years. A pool of amateur typists – including the Velvet Underground drummer Maureen Tucker – were responsible for the transcript, and typos and other errors were deliberately left in. The final work drew comparisons in some quarters to *Ulysses* – Warhol's interest in the Joycean twenty-four-hour 'day in the life' format also found expression in the epic film **** – but the *New York Review of Books* denounced it as 'pornography' and said it tolled 'the death knell of American literature'.

The title *a* – standing for 'amphetamine', Ondine's narcotic inspiration for his verbal barrages, as well as 'Andy' – was apparently suggested by Billy Name. By the time the book appeared, Name was ready to quit his hermit-like occupation of the darkroom and depart the Factory once and for all. Security had been increased and many of the old superstars found themselves excluded. Morrissey was keen to keep out anyone of 'tenuous mental health' – a description that would probably have covered most of the regulars at the old Silver Factory. Warhol was worried that not having 'the crazy, druggy people around jabbering away and doing their insane things' would have an impact on his creativity. 'They'd been my total inspiration since 1964,' he observed. Name did not approve of the transformation of the Factory into a business or the fact that, in his view, Warhol had become 'Cardboard Andy'. One day, Warhol found a note pinned to the door that read simply: 'Andy – I am not here anymore but I am fine. Love, Billy.' Swiftly, the darkroom was painted white and a Xerox machine installed. A new era had dawned.

7

Media Mogul

The new decade would see Warhol quitting the anti-establishment underground for the daylight elite and setting himself up as portraitist to the international jet set. The art world was radicalizing but, as so often in his career, Warhol would do the opposite, making a turn towards 'business art' and setting up Andy Warhol Enterprises, Inc., as a real corporation. Whereas in the sixties he had looked to home – the Factory – for inspiration, now he would go out to find his subjects in a heroic feat of relentless socializing. Attending three dinner parties a night, he sought out 'victims' to snap Polaroids of and then turn them into silkscreened portraits for a handsome commission fee. He took his camera and tape recorder – he referred to the latter as his wife – everywhere with him. 'The acquisition of my tape recorder really finished whatever emotional life I might have had, but I was glad to see it go,' he declared.

Warhol's celebrity meant that his face and name would increasingly be deployed as a kind of brand trademark, a shift evident in the late 1960s ad for Braniff Airlines, showing him seated next to Sonny Liston and chatting to the stony-faced boxer about Michelangelo and the beauty of soup cans. 'Talkative Andy Warhol and gabby Sonny Liston always fly Braniff,' runs the voiceover. 'They like our girls, they like our food, they like our style.' Warhol himself delivered the ad's punchline: 'When you got it, flaunt it!'

'Before I was shot, I always suspected I was watching TV instead of living life,' Warhol reflected. 'Right when I was being shot I knew

I was watching television.' Perhaps unsurprisingly, he began kicking around an idea for a TV show to be called – in typically flat, impassive Warholian fashion – *Nothing Special*. Nothing would come of that idea for another ten years. However, in late 1969, he did broaden his brand activities to incorporate a magazine. *Interview* (or *Inter/VIEW*, as it was initially written), edited by Gerard Malanga, was billed as a 'Monthly Film Journal'; the black-and-white cover of the first issue featured the French filmmaker Agnès Varda forming one of three human uprights to Viva's horizontal naked form. Its first appearance coincided with the New York Film Festival and provided Warhol with access to free passes to screenings.

Warhol's cinematic ambitions had not faded, although the Factory would no longer serve as set or inspiration for his filmmaking. Avant-garde in spirit and low-budget in realization, *Easy Rider* (1969), directed by Warhol's old friend Dennis Hopper, helped to inspire a new spirit in US filmmaking; the so-called New Hollywood was born out of its critical and commercial success. With its storyline about two bikers riding across America on the proceeds of a cocaine deal, and showing open and real marijuana use, it made Warhol and his team want to shoot their own quasi-mainstream film about drugs. *Trash* starred Joe Dallesandro as a sexually ambivalent hunk in search of his next heroin hit, whose addiction is preventing him from getting an erection. As its writer-director Paul Morrissey avowed, at heart *Trash* was an anti-drug film.

Not that Warhol and his crew were renowned for their moralizing. Police had seized the print of *Blue Movie* on grounds of obscenity when it finally opened. *Lonesome Cowboys* suffered a similar fate in Atlanta. Law-enforcement officers in London went one better in January 1970 when they raided a screening of *Flesh*, seized the print and arrested the audience too. The incident gave rise to a debate in the House of Commons. The official film censor averred that, although

it was not his 'cup of tea', there was 'nothing at all corrupting' about the film. (Warhol once insisted: 'But I really do think movies should arouse you, should get you excited about people, should be prurient.')

When *Trash* was released in October 1970, the reviews were generally admiring, even if they withheld complete endorsement. Gene Siskel of the *Chicago Tribune* wrote: 'The Warhol-Morrissey world is a strange one, but in many ways, especially if taken in infrequent doses, a far more real world than the formula Hollywood drama or comedy. The actors are solidly in touch with their madness and can improvise with wit.' This chimed with something Warhol said of the contrast between the Factory and Hollywood: 'They're not real people trying to say something. And we're real people not trying to say anything.' In his review, Bob Colacello, who would in due course become editor of *Interview*, hailed it as a 'great Roman Catholic masterpiece'. But perhaps the most unexpected bit of praise took the form of the Oscar-winning 'Old Hollywood' film director George Cukor, who had been featured in the first issue of *Interview*, campaigning to get the transgender actor Holly Woodlawn – born Haroldo Danhaki in Puerto Rico in 1946 – nominated for an Academy Award for her performance. He did not succeed, but *Trash* ended up grossing $1.5 million, making it Warhol's most commercially successful cinema release.

Andy was largely absent during the shooting of *Trash*, but was much more involved in the making of its successor. Indeed, *Women in Revolt*, 'a madcap soap opera' about the feminist movement, was the last film for which Warhol would himself shoot scenes. The script and overall direction were again the work of the socially conservative Morrissey, although the film's satirical ambivalence towards its subject matter – elements of the production could 'be interpreted as the ultimate put-down of women's lib, as well as the ultimate endorsement', to adopt Vincent Canby's phrase from his *New York Times* review – may in part have stemmed from Andy's feelings

towards Valerie Solanas. The roles of the 'three manic heroines' were taken by the trans superstars Jackie Curtis, Candy Darling and Holly Woodlawn; *Women in Revolt* followed their characters in different stages of liberation, quitting their confined, gender-determined roles (schoolteacher, socialite) to join the Movement and become Politically Involved Girls, or PIGS.

The dialogue is often 'foolish and occasionally inspired in the way that good parodies must be', Canby observed. One of the most memorable lines is delivered by Curtis, playing a schoolteacher who is still a virgin and so sleeps with a former Mr America so that she can 'find out what we're fighting against'. 'This can't be what millions of girls commit suicide over when their boyfriends leave them,' she ad-libs after administering a blow job.

When Warhol was unable to find a distributor for the film, he rented a cinema on East 59th Street, off Third Avenue, to launch it – and found the screenings picketed by women's liberationists, who assumed that he was poking fun at them. 'Andy, as usual, denied everything,' remembered Colacello, although he was clear about his real intent: 'PIGS was his answer to SCUM.' In an interview with the *New York Times*, Fred Hughes said the Factory team were in favour of equal rights for women: equal pay, free abortions – 'And lipstick for both men and women,' added Warhol.

Warhol spent the 1970s in pursuit of rich patrons for private portrait commissions, charged at a standard $25,000 apiece. His strategy worked. A few years into the new decade, business was booming: by 1974, he was taking more than a million dollars a year in commissions. He would justify this strategy by insisting that he was essentially 'a commercial person': 'I've got a lot of mouths to feed, gotta bring home the bacon.'

The modus operandi sounded simple enough, although it could be quite time-consuming: Warhol took Polaroids of his subjects

using a non-adjustable lens and then sent the chosen snapshots to be converted into positive proofs the size of the final painting. The image was then traced on to canvas, with key features being painted in – background colour, eyes, lips – before the canvas was sent away for the black-and-white image to be silkscreened on top. 'Warhol transforms his "sitters" into glamorous apparitions, presenting their faces as he thinks they should be seen and remembered,' wrote the art critic David Bourdon. 'His portraits are not so much documents of the present as they are icons awaiting a future.'

Warhol's pursuit of wealthy patrons drew criticism of his 'moral indifference' and 'exaltation of "Fascist chic"' from former supporters on the left. Among his more controversial targets were the Pahlavi regime in Iran and Imelda Marcos, whose conspicuous consumption caused one US congressman to note that she made Marie Antoinette look like a bag lady. The First Lady of the Philippines became so enamoured of Andy's dachshund Archie that she invited him to come and hang out with her own canine consorts in Manila; Warhol accompanied her to the Chinese embassy, where he was subjected to a screening of propaganda films featuring Madam Marcos talking to the Communist Party leader (and Warhol portrait subject), Mao Zedong. He also watched as she led the opening of the Filipino Cultural Center on Fifth Avenue and chants of 'Imelda, go home!' rang out from an angry crowd. After her husband imposed martial law in Manila, she spent significant spells of time in New York adding to her shoe collection. She liked to party – her townhouse on East 66th Street had a disco ball among its fixtures and fittings, and she performed a memorable rendition of 'The Yellow Rose of Texas' – and invited Warhol to her gatherings at the Plaza. If Andy could bring a glamorous companion – Jacqueline Onassis's sister, Lee Radziwill, or Diane von Furstenberg, for instance – all the better.

It was not just faces that Warhol wanted to photograph. Whenever

a male visitor stopped by the Factory, Andy was in the habit of asking – 'no matter how straight-looking he was,' he underlined – whether the guest might be willing to drop his pants so a Polaroid could be taken of his cock and balls. Many agreed. And Warhol got as close as was imaginable to putting one of the resulting images on the cover of a chart-topping album. In April 1969, Mick Jagger, who was familiar to both the Factory and Max's Kansas City scenes, wrote to Warhol to thank him for agreeing to do the artwork for their next release and counselled him to keep the format simple. Perversely, Warhol responded by creating one of the most technically challenging album sleeves in recorded-music history, incorporating a real, functional zip. It also featured one of the most risqué cover images ever to hit store shelves: a shot of a bulging, jean-clad crotch that revealed the model's underwear when the zip was lowered. Jagger was right about the risks of such design complexities: the zippers made it difficult to stack the records for shipping and could scratch the vinyl discs within. Many assumed, wrongly, that the crotch in question belonged to Jagger. Indeed, the jeans model and the underwear model may not even be the same person.

Warhol took waist-down portraits of a number of people, including his lover Jed Johnson, future *Interview* editor Glenn O'Brien, and Factory superstars Joe Dallesandro and Jackie Curtis. O'Brien recounted that as he was posing for his shot, trousers around his ankles, Warhol kneeling with his Polaroid in front of his crotch and Fred Hughes standing by and urging, 'Can't you make it any bigger?' a huddle of men in suits looking for the architect's bureau next door wandered in by mistake. They would probably not have guessed that they were witnessing the cover shoot for the next Rolling Stones album.

Warhol now dipped a toe in curatorial waters. In April 1970, following a brief tour, *Raid the Icebox I* opened at the Rhode Island School of Design Museum. Warhol had been asked to put together a

show from the 35,000 items in the RISD's collection that were in its basement storage space, which the museum's regular curator, Daniel Robbins, compared to a 'junk shop'. Ignoring curatorial convention, Andy delighted in duplications and approached the exercise in the same way that he approached his private but increasingly expansive collecting activities: like an enthusiastic shopper. He took particular pleasure in the shoe collection – sabots, ballet shoes, boots – and in the final selection brought parasols and hatboxes together with drawings and textiles. At the press preview, Warhol got one of his superstars, Jane Forth, to answer questions for him, then made his exit, to the disappointment of the six hundred people attending the opening.

In May 1971, Warhol made his first venture into theatreland when *Andy Warhol's Pork* – his name would increasingly be deployed as a marketing tool in the titles of projects – premiered at the La MaMa Experimental Theatre Club in New York. The script was worked up from taped telephone conversations between Warhol, Brigid Berlin and others, a crowd-sourced writing method he had already used in the creation of *a (a novel)*, and one that would achieve its apotheosis with *THE Philosophy of Andy Warhol* a few years later. Various members of the Factory crowd were satirized in the script, including Warhol himself, who appears as 'B. Marlowe, a deadpanned, flaxen haired voyeur who Warhol-ishly keeps a Polaroid at the ready', as Grace Glueck noted in her *New York Times* review.

After its New York run, *Pork* played at the Roundhouse in London, where the Brigid Berlin role was taken by Cherry Vanilla; she recounted Andy calming her audition nerves by asking her to sing a hymn from her Catholic school. The production was seen by a rising music star named David Bowie, then in the process of recording *Hunky Dory*. Bowie would include a song entitled 'Andy Warhol' on the album, and was so inspired by his new art hero that he made his way to the Factory to perform the song to Andy in person.

In September 1971, decked out in floppy hat, Oxford bags-style trousers and Mary Jane shoes with odd socks, Bowie sang 'Andy Warhol' to Andy Warhol. The response was polite but muted, and Bowie left unsure whether the song had been a hit with its subject. It had not; morbidly sensitive about his appearance, Warhol did not like the line declaring he 'look[ed] a scream'.

Part of the visit was captured on video: Bowie was filmed performing a mime routine in which he cuts out his heart. Warhol had bought portable video equipment in 1970 and it became a favoured new way of documenting his and his entourage's existence, in and beyond the studio; a supplement to his ubiquitous photographing and tape-recording activities. The *Factory Diaries*, as they were named, continued until 1982 and recorded many resonant scenes: Julia Warhola in bed; the 'Rectal Realist' painter Neke Carson painting Andy; Andy and Jed at their Montauk estate discussing their dog Archie's health before being interrupted by Fred Hughes's announcement that people were having sex on the beach; Warhol delivering a video letter for Man Ray following the artist's death.

Shortly after his visit to the Factory, in November 1971, Bowie began to record his next album, about a bisexual alien rock star named Ziggy Stardust. Jayne County, who travelled to London with *Pork* and met Bowie at the time, was convinced of the influence of Warhol and the production on Bowie's new stage persona: 'if it hadn't been for *Andy Warhol's Pork*, there would never have been... a Ziggy Stardust.' Shortly afterwards, Lou Reed, also often cited as providing crucial inspiration for Ziggy Stardust, gave the Factory scene what the Velvet Underground had never been able (and probably never intended) to: a hit on the pop charts. 'Walk on the Wild Side' had verses about Joe Dallesandro, the Sugar Plum Fairy and the three trans stars of *Women in Revolt*: Holly Woodlawn, Candy Darling and Jackie Curtis. The blossoming of glam rock with its flamboyant subversion

of traditional attitudes to gender marked another high point for the influence of Warhol's Factory world on the cultural mainstream.

The first years of the 1970s also, appropriately, brought the mounting of a major Warhol retrospective in the USA. The curator, John Coplans, said he had never known an artist express him- or herself with greater concision or simplicity on the subject of the contents of a retrospective of their work: none of the early hand-painted works were to be shown; series only. Traditional retrospectives were old-fashioned. The show opened at the Pasadena Museum in California in May 1970, then travelled to Chicago, Eindhoven, Paris, London and, finally, the Whitney Museum in New York.

The opening at the Whitney on 26 April 1971 represented something of an art world deification for Warhol. The museum's walls were covered with the magenta and green *Cow Wallpaper*, and hung with works from the *Campbell's Soup*, *Death and Disaster*, *Flower* and *Marilyn* series. Everything seemed huge in scale. The critic Barbara Rose declared Warhol 'the Zeitgeist incarnate' and his images 'the permanent record of America in the sixties', while Calvin Tomkins reflected: 'Andy is the first real art celebrity since Picasso and Dalí... Always somewhat unearthly, Warhol became in the 1960s a speechless and rather terrifying oracle. He made visible what was happening to some part of us all.'

The third film in the Morrissey Trilogy, *Heat*, was filmed in Los Angeles in June 1971. It was a satire on Billy Wilder's Hollywood tragicomedy *Sunset Boulevard* (1950), with Sylvia Miles in the Gloria Swanson role and Dallesandro again playing a hustler who uses sex, this time not to obtain drugs but to get a rent reduction. The Warhol superstar Andrea Feldman, who had played a drug-crazed teen in *Trash*, was cast as Miles's psychotic daughter.

A survivor of the Factory scene's madness, Holly Woodlawn later reflected on the experience of being a Warhol superstar: 'You

live in a hovel, walk up five flights, scraping the rent. And then at night you go to Max's Kansas City where Mick Jagger and Fellini and everyone's there in the back room. And when you walked in that room, you were a STAR!' Not that she ultimately regretted her Faustian pact: 'it was worth it, the drugs, the parties, it was fabulous.' Others disagreed. Andrea Feldman, a heavy amphetamine user, was another back-room regular at Max's, where she was known for getting up on a table and performing a striptease routine she called 'Showtime'. When she began to call herself 'Andrea Warhola', seemingly in the hope that Andy would marry her, and appeared at the Factory covered in scabs, Warhol said she was 'just going through a phase'. She never came out of it. With the release of *Heat* only weeks away, she invited friends to her parents' Fifth Avenue apartment to 'see something special', and threw herself from the window, a rosary in her hands.

On 16 November 1971, after a long struggle with alcohol and drug abuse, the best-known of the Warhol superstars, Edie Sedgwick, died. On learning the news, Warhol reportedly asked whether he would inherit her money.

As she approached her eightieth year, Julia Warhola was in serious mental and physical decline, so it was decided that she should go and live in Pittsburgh with Andy's brother Paul. In February 1971, already stricken with Alzheimer's, she suffered a stroke and was moved to a nursing home. Warhol called her every day, but, although she begged him to visit, he would never see his mother again. When she died, on 22 November 1972, two days after her eighty-first birthday, Warhol paid for her to be buried next to his father in the St John the Baptist Byzantine Catholic cemetery in Bethel Park, but he did not attend the funeral, and did not tell anyone about her passing until two years later: not even Jed Johnson, with whom he was now living. He would memorialize her in a silkscreened portrait completed in 1974,

applying the last paint marks with his fingers. Death, for Warhol, was 'abstract' – a bit like going to Bloomingdale's, he said – but after Julia's death his nephew George Warhola remembered witnessing his uncle take off his wig and sit with one of her handkerchiefs draped over his head. 'Andy was always the little boy with Julia,' noted Gerard Malanga.

But Warhol was moving on. His new circle of friends – Diana Vreeland, Paulette Goddard, Halston, Bianca Jagger – were more uptown than underground, and *Interview* would provide him with a new pathway to the stars. Although he quipped that he had created the magazine to give Gerard Malanga something to do, by 1973, having run through a dozen editors, it was making substantial financial losses, so a decision was taken to recast it and make it more professional. It would no longer be an indie movie publication written by poets and artists. 'Let's make it a magazine for people like us!' said Fred Hughes, by which he meant that it should turn to look outwards and upwards from the underground scene to the worlds of celebrity and conspicuous consumption.

An ambitious young conservative called Bob Colacello was appointed editor of this pioneering style and gossip magazine, which fused the worlds of music, art and fashion. His regular diary column, 'Out', detailed the Factory crowd's social life: what they ate and wore, where they went and who they socialized with. Ad revenues and circulation numbers began to rise. From 1972, Richard Bernstein created the highly distinctive cover portraits, painting over photographs of stars. As Warhol said, 'He makes everyone look so famous.' Of course, most of the people featured *were* famous: part of the magazine's USP was getting celebrities to interview one another. Warhol joined in, failing to prepare his questions and then letting his tape recorder run, leaving the results to be transcribed by someone else afterwards.

Some of Warhol's backers were growing restless at his tireless pursuit of commercial portrait commissions. His dealer Bruno Bischofberger was agitating for him to return to painting subjects worthy of a gallery show: for instance, the greatest figures of the twentieth century. Einstein was mooted. In the event, Warhol settled on Mao Zedong, seemingly because, in the wake of US President Richard Nixon's historic visit to the People's Republic in 1972, *Life* magazine had just declared the Chinese leader the most famous person in the world. Warhol was becoming very bold in trying to persuade the most forbidding clients to submit to his Polaroid camera so that he could do their portrait. On this occasion, however, no approach was made to Mao personally, and Warhol instead appropriated the iconic portrait from the frontispiece to the 'Little Red Book' as his source. In the space of just three months he produced an astonishing number of silkscreened images. The colour selections seemed to add deft comedy, and there were hand-painted touches, which, Warhol explained, were 'in fashion' now.

Henry Geldzahler revelled in the irony that the images of the Communist world's most recognizable leader had been 'produced cheaply to be sold dearly by an artist in the capitalistic capital of the world'. When the work was unveiled in Paris in February 1974, the paintings were displayed mounted on Mao wallpaper. In London, a show of preparatory drawings saw the *Times* hail Warhol as 'the most serious artist to have emerged anywhere since the war', comparing him to Oscar Wilde: 'He hides a deep seriousness and commitment behind a front of frivolity.' The writer was equally convinced that the series represented 'an absolute condemnation of American capitalist society'.

There was obvious condemnation of the US President, if not of capitalist society as a whole, in another project Warhol undertook at this time. As George McGovern prepared to challenge Richard Nixon in the 1972 presidential campaign, his supporters asked Warhol to

create work in support of the Democratic hopeful. Warhol obliged, although his *Vote McGovern* series actually featured a portrait of his political opponent. Colouring his skin a ghastly blue-green and setting it against a violently clashing vibrant orange background, Warhol made Nixon look like one of his favourite characters: the Wicked Witch of the West.

On the subject of his political allegiance, Warhol joked: 'I just do anything anybody asks me to do.' In August 1976, after the *New York Times Magazine* commissioned him to do a cover portrait of Democratic presidential candidate Jimmy Carter, the Carter team asked Warhol to give an edition of a hundred prints to raise money for his campaign. As a reward, Carter, who had a peanut farm, gave him signed bags of peanuts. Warhol said he liked Carter's smile, commenting: 'Politicians have twenty-four-hour smiles. So do dogs.'

Warhol, portraitist to the international jet set, was becoming something of an international jet-setter himself as he flew regularly between the US and Europe. In summer 1973, his latest movie projects – *Flesh for Frankenstein*, to be made in 3D, and *Blood for Dracula* – saw him commuting between Italy and New York. Paul Morrissey was credited as writer-director of both projects; when Warhol was asked what his contribution was, he said: 'I go to the parties.' Not that he contributed no ideas to them; the German actor Udo Kier remembered that Warhol thought Dracula should wear shiny pants and have a constant erection, but the Italian producer tutted: *Non è possibile*. Both films could be seen as having personal reference to Warhol: his Factory nickname was Drella – Dracula/Cinderella – while in *Flesh for Frankenstein* the monster's scarred torso was richly displayed, like Warhol's in the Avedon images, and the good doctor cries: 'To appreciate life, you must first learn to fuck death in the gallbladder!' Already a problem for him, Warhol's gallbladder would be his ultimate undoing.

At the same time, Warhol realized a fantasy when he got his first film role, in a project entitled *The Driver's Seat*. According to the script, Warhol's character was 'a rich creep of undisclosed nationality and occupation'. 'Gee,' Bob Colacello remembered Warhol reflecting, 'my first movie and I'm typecast already.' Warhol thought the movie, which was also shot in Rome, full of potential for other reasons, since its star was one of his idols: Elizabeth Taylor. Andy was keen to take Polaroids of her so that he could make a new portrait. But 'Liz', as he instinctively called her, much to the Hollywood star's displeasure, proved elusive, constantly adjudging herself 'too puffy' – she was drinking heavily – to pose for his camera.

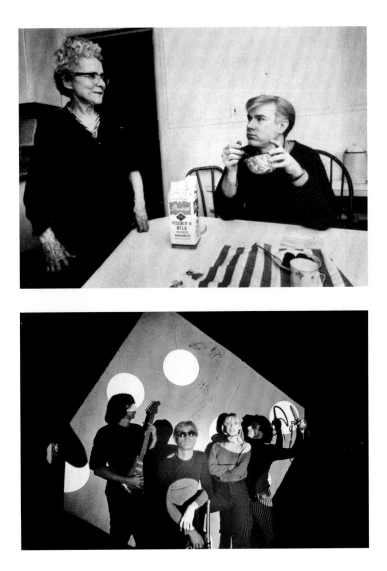

TOP – Eating cereal in the company of his mother, Julia.
ABOVE – Preparing for the Exploding Plastic Inevitable with Nico, the Velvet Underground and Gerard Malanga (with whip), 1966.

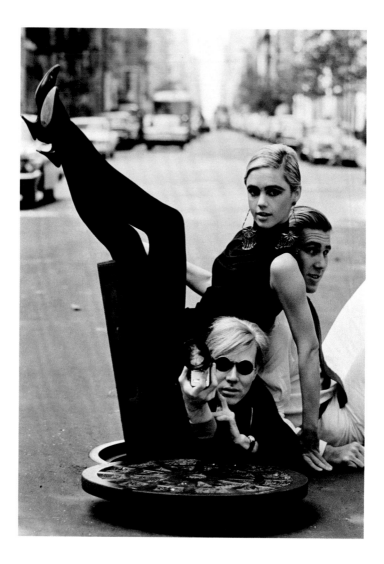

In the street with Edie Sedgwick and Chuck Wein.

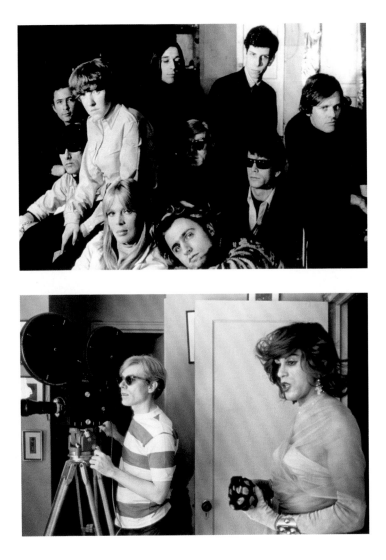

TOP – With the Velvet Underground, Nico, Paul Morrissey and
Gerard Malanga, 1966.
ABOVE – With Mario Montez on the set of *The Chelsea Girls*, 1967.

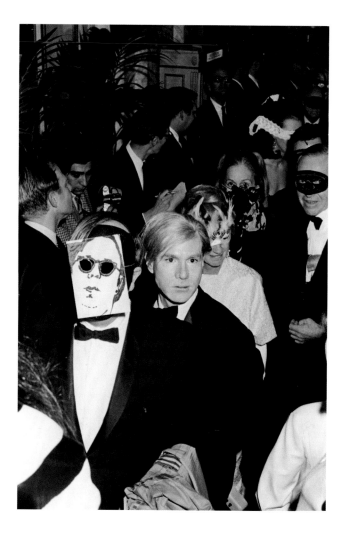

ABOVE – Without a mask at Truman Capote's masked Black and White Ball
at the Plaza Hotel, New York, 28 November 1966.

OPPOSITE PAGE
TOP – With Viva and Taylor Mead on the set of *Nude Restaurant*, 1967.
BELOW – With Tennessee Williams and Paul Morrissey on the SS *France*, 1967.

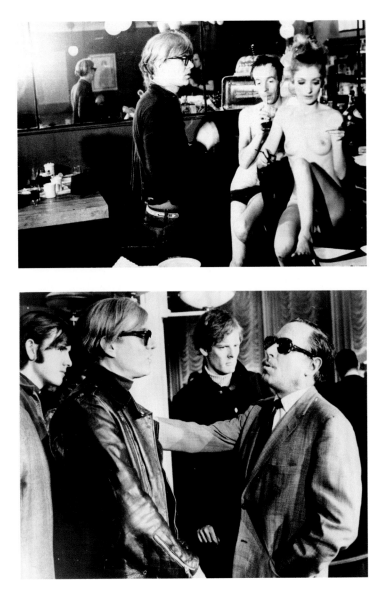

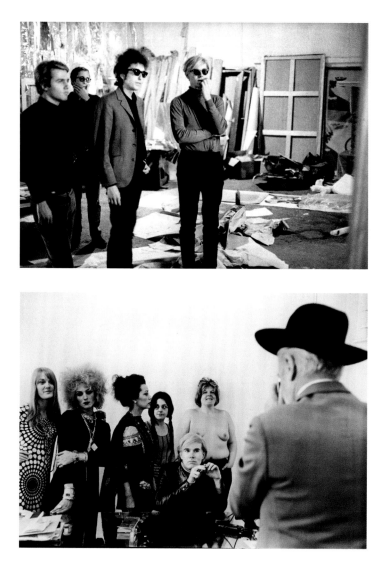

TOP – With Gerard Malanga, Danny Williams and Bob Dylan at the Factory, 1965.
BELOW – Being photographed by Cecil Beaton with Ingrid Superstar, Candy Darling, Ultra Violet and Brigid Berlin at the Factory, 1969.

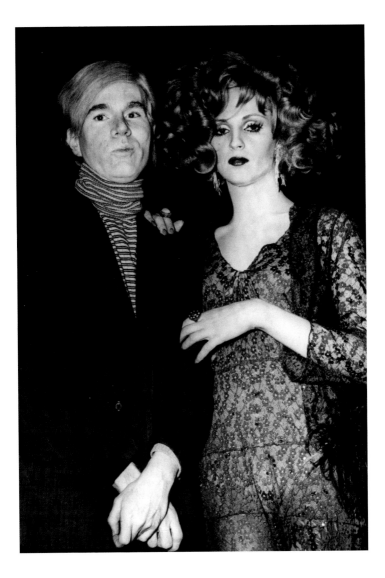

TOP – With Candy Darling at the premiere of *Midnight Cowboy*
in New York, 25 November 1969.

ABOVE – In surgical corset and with scars on show after the assassination attempt by Valerie Solanas, 1968.

OPPOSITE PAGE
TOP – With the cast of *Andy Warhol's Pork* at the La MaMa Experimental Theatre Club, 1971.
BELOW – With Paul Morrissey, Udo Kier, Vittorio De Sica and Arno Juerging on the set of *Blood for Dracula* in Cinecittà, Rome, 1974.

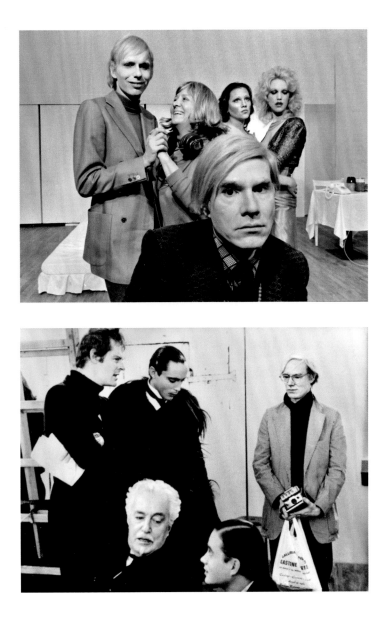

With Halston, Bianca Jagger, Jack Haley Jr., Liza Minnelli
and more at Studio 54, New Year's Eve, 1978.

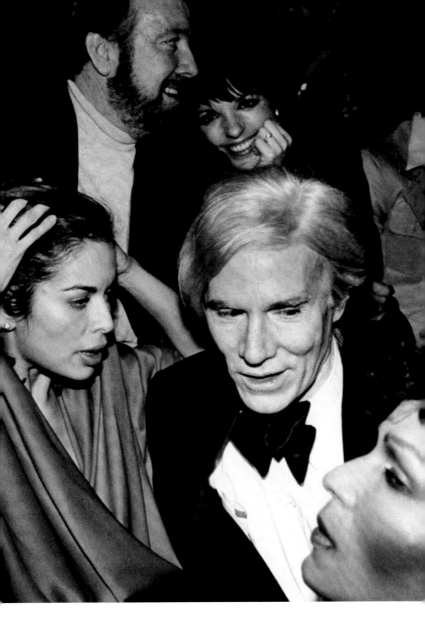

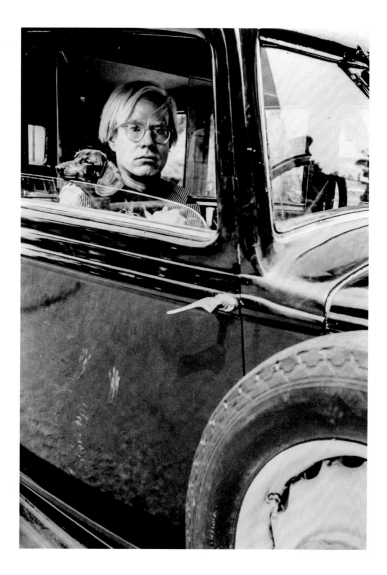

Behind the wheel with his dachshund, Archie.

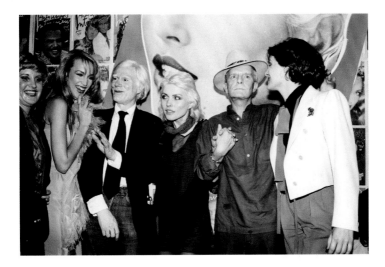

With Jerry Hall, Debbie Harry, Truman Capote and Paloma
Picasso at an *Interview* party at Studio 54, June 1979.

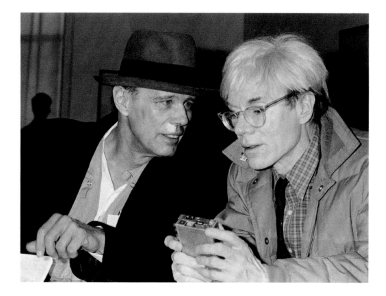

With Joseph Beuys, 1982.

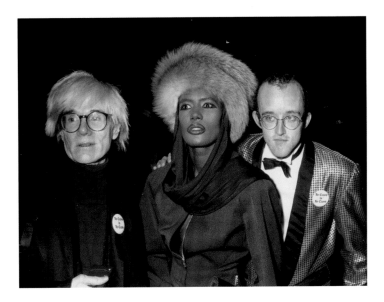

With Grace Jones and Keith Haring at the American Foundation for Aids
Research fundraiser at the Jacob Javits Center, New York, 1 May 1986.

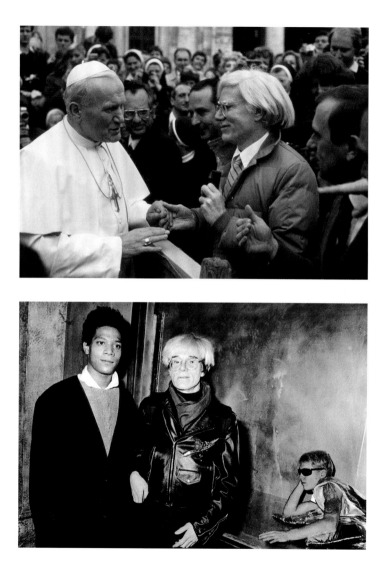

TOP – With Pope John Paul II in Vatican City, 2 April 1980.
ABOVE – With Jean-Michel Basquiat at a benefit for the Brooklyn Academy of Music at Area Nightclub, New York, 7 November 1984.

8

High Society

'**B**usiness art is the step that comes after Art,' Warhol famously said. 'I started as a commercial artist, and I want to finish as a business artist.' In the early 1970s, he made good progress towards realizing his grand ambition, and in August 1974 he had to move offices to accommodate his ever-expanding commercial interests. The new premises were on the third floor of 860 Broadway, at the north end of Union Square, not very far from the Second Factory; frugally, Warhol got visitors to help carry items between the two addresses. It was as he was preparing the move that he began to assemble the boxes that would become his next great documentary project, the *Time Capsules*. By the time of his death, there would be more than six hundred of them.

Back in March 1974, Warhol had signed to do a book with the publisher Harcourt Brace Jovanovich. The following year, when *THE Philosophy of Andy Warhol (from A to B and Back Again)* – the original title was just *THE* – was ready for publication, *New York* magazine published an article announcing 'Andy Warhol's Greatest Secret: He Likes to Write'. That was not strictly true – Warhol was not the book's author, at least not in the traditional sense – but he had agreed to pose sitting at a typewriter to illustrate the piece anyway.

As with his art and film work, Warhol had created a Factory assembly line to produce his highly idiosyncratic and autobiographical Book of Wisdom. The principal literary labourers were Bob Colacello, Warhol's friend and collaborator Pat Hackett and editor Steven M.L. Aronson; Brigid Berlin was also an important contributor, since

she was the 'B' to Andy's 'A' in the book's title, and the person on the other end of the line when Warhol wanted to talk on the phone. Colacello noted that Warhol's own approach to writing was essentially quantitative and recording-based. 'It was never "Write the Sex chapter." It was "Let's do a ninety-minute tape for the Sex chapter,"' he noted. But he also allowed that Warhol demonstrated a remarkable mixture of clarity of vision and abstract intuition in shaping the book. For instance, the opening section, 'How Andy Puts his Warhol On', was initially drafted by Colacello, but at twelve pages Warhol considered it too short, so he read it over the phone to Brigid Berlin, who interjected comments. Warhol then handed the tape of the telephone conversation to Pat Hackett to transcribe and improve. As ever, Warhol had scant regard for the idea of originality, and had descriptions of himself drawn from the Factory press clippings book recycled into the text as though emanating from his own mouth: 'the chalky, puckish mask, the slightly Slavic mask… The childlike, gum-chewing naïveté, the glamour rooted in despair, the self-admiring carelessness, the perfected otherness.' He still enjoyed being ventriloquized.

The book contains many Warholian aperçus and bits of gossipy advice. There is the insight about America's greatness lying in 'the tradition where the richest consumers buy essentially the same things as the poorest… the President drinks Coke, Liz Taylor drinks Coke… A Coke is a Coke and no amount of money can get you a better Coke than the one the bum on the corner is drinking.' And there is his 'So what' philosophy of life. Were you unloved by your mother? Is your partner indifferent to your physical charms? Do you find yourself wealthy but alone? Refuse to waste time agonizing about your plight, just say: *So what*, counselled Warhol (via Colacello, Hackett et al.). 'I don't know how I made it through all the years before I learned how to do that trick,' he/they added. 'It took a long time for me to learn it, but once you do, you never forget.'

The critical reception left Warhol in little need of 'so what'-style indifference to life's asperities, since he found himself being compared by the critics to the great French aphorist La Rochefoucauld. By contrast, his co-writers – who were unhappy about the way credit was given publicly and money shared privately – were perhaps in need of the consolations of philosophy.

Warhol was keen to publicize the book, and had gone to a New Jersey warehouse to sign six thousand copies of the first print run as a promotional ploy. In September 1975, he set off on an eight-city, cross-country promotional tour. His entourage consisted of Fred Hughes, Jed Johnson, Bob Colacello and Lady Anne Lambton, daughter of the Conservative MP Lord Lambton (Andy had a thing for assistants drawn from the Anglo-Irish upper classes). Warhol was mobbed at the first signing, at the Museum of Fine Art in Baltimore, which set the tone for subsequent events in Ann Arbor, Chicago, Minneapolis, Los Angeles, San Francisco, Houston and St Louis. Hordes of devotees turned up to have books, posters, T-shirts and, inevitably, cans of Campbell's soup signed by the master.

While Warhol, attended by the twenty-one-year-old Lambton, met his fans and did his 'Duchamp number', autographing ordinary objects, the other members of the group busied themselves with their various duties. Hughes had meetings with local curators and museum directors, Johnson went antiquing for Art Deco and American Empire treasures, and Colacello did the rounds to try to increase *Interview*'s distribution network. In Houston, Warhol and Lambton, whom he insistently introduced as his fiancée, posed like mannequins in a department store window to the piped accompaniment of 'Heroin' by the Velvet Underground.

In October, Lord and Lady Lambton gave a party to mark the British publication of *THE Philosophy* at their London townhouse, with plenty of heavy-hitting socialites on the guest list. Caroline

Kennedy, Jackie's seventeen-year-old daughter, made the front page of a London tabloid when she left in the company of the handsome heir to a sizeable industrial fortune. Depending on whose account of proceedings you believe, Jackie later thanked Warhol for taking care of her daughter, much to Warhol's bemusement – 'I wasn't sure what she meant' – or blamed him for *not* taking care of her, at which point Warhol denied all responsibility. Both versions ring true. When Lord Lambton thanked him for taking care of *his* daughter, Warhol deadpanned that she was the hardest-working bodyguard he had ever had.

Progress on a second book, a tell-all account of the life of the Hollywood film star Paulette Goddard entitled *HER*, proved halting. Goddard had previously begun work on an autobiography, then provisionally called *The Perils of Paulette*, with her friend Anita Loos, screenwriter and author of the novel *Gentlemen Prefer Blondes*. Dissatisfied with the results, Goddard had moved on to Warhol, promising major revelations about the many stars she had met, to be delivered in conversation with her 'white fox', as she dubbed Warhol. Initial relations were so warm that the papers predicted not just a book but a wedding too. But there was a distinct cooling in the friendship after the contract was actually signed and the real work began. An interview session was planned at the Regency Hotel, and, as ever, Warhol came accompanied by Sony, but Goddard brought a recorder too, and her lawyers followed up with strict requirements about the use of any resulting tapes. To Warhol's frustration, conversation was always stilted on the subject of Goddard's most famous former squeeze (and second husband), Charlie Chaplin. In particular, she did not appreciate being asked by Andy, as was his wont with all interviewees, about the size of the Little Tramp's cock. The book never appeared; Warhol and Goddard never married.

'Andy's life now settled into the daily routine he would follow until his death,' Colacello recorded. A typical day would begin with him calling Pat Hackett to do his diary – the original purpose of this was to log his business expenses, but, as Hackett explained, it 'came to have the larger function of letting Andy examine life' – before making his way to the Factory for lunch with clients. Afternoons would be reserved for painting, before a long evening of parties and dinners spent in pursuit of 'victims': 'always handing out *Interview*; snapping photos; tape recording; and making sure always to get a receipt everywhere he went.'

Between the call to Hackett and lunch, said Colacello, Warhol would 'shop his way downtown', scouring flea markets and junk shops as well as more upscale stores and auction rooms for both museum-quality art and kitschy trinkets. Andy collected everything – or rather, he *bought and kept* everything, often just depositing bags containing his new purchases on a table when he got home and leaving them unopened for weeks or months, or indeed until his death. In 1987, Sotheby's sent a team of appraisers to catalogue his possessions for auction; they eventually inventoried ten thousand items, a significant number of which were still in their shop wrappings when they were discovered. In the same way that he did as an artist, as a collector Warhol liked to mix high and low: portrait busts of Napoleon and Benjamin Franklin, Art Deco chairs, a Federal dining table and four-poster bed, Bakelite bracelets, vending machines. Warhol's collection of campy ceramic cookie jars included upright piggies, clowns and Disney characters, staples of Pittsburgh homes during his youth. At auction, the cookie jars alone would bring in $247,830.

Warhol's 'candy box' house on Lexington Avenue was too small to contain all these wonders, so he moved to a four-storey Georgian-style mansion at 57 East 66th Street on the Upper East Side. Perhaps

the change of address was also a way to escape the ghost of his mother. Johnson, who lived there with him, decorated it in a grand European style. Amid all the rugs and cigarette cases they found room for only one work by Warhol: a Mao painting. Andy hired two Filipino maids, Nena and Aurora Bugarin, who would run his household for the rest of his life. The mansion was grand enough to entertain in – old friends such as Truman Capote and Diana Vreeland were invited – but Warhol never settled to this routine; his social world was increasingly kept out of both his studio and his home. According to Johnson, every morning and night Warhol would tour the house, unlocking each room to peer in before securing the door again. He was rich but still kept cash under his mattress. In the Sotheby's auction catalogue, Johnson observed: 'It was inconspicuous consumption. He'd wear a diamond necklace, but only *under* a black cotton turtleneck.'

Paul Morrissey departed Warhol's coterie in 1975, following the failure of *Man on the Moon*, Warhol's only Broadway venture. The space-themed musical, directed by Morrissey and written by John Phillips, formerly of the Mamas and the Papas, closed almost before it had opened. Clive Barnes in the *New York Times* opined, 'For connoisseurs of the truly bad, *Man on the Moon* may be a small milestone.' As it so happens, Warhol's new film project was called *Bad* – or rather, *Andy Warhol's Bad*. Like *Women in Revolt*, it riffed on female liberation, this time featuring a group of women who were pillars of society by day and amoral hitwomen by night, led by Hazel, a hairdresser who specializes in hair removal: she boasts an ability to do '650 hairs an hour'. Filmed in New York in spring 1976, and directed by Jed Johnson to a script by Pat Hackett, it had a budget of $1.5 million, three times more than any previous Warhol production; cast and crew included a large number of industry professionals for once. But it was a failure – audiences did not warm to the baby-killing

scene; perhaps they did not recognize it as a homage to the Odessa Steps sequence in Sergei Eisenstein's silent classic *Battleship Potemkin* – and it proved to be Warhol's final commercial release.

His filmmaking fantasies at an end, television would become Warhol's abiding obsession. In 1978, Lorne Michaels, the creator of the satirical NBC show *Saturday Night Live*, offered to make *Nothing Special* a primetime reality, but Warhol decided to launch his own local cable show instead. Initially entitled *Fashion* and conceived as a 'fashion magazine on TV', it developed into a variety show, with Warhol talking to friends, cultural figures and rising music stars such as Henry Geldzahler, Diana Vreeland and Debbie Harry. 'Cable TV is the ultimate America,' proclaimed Warhol. It was not until 1985, when MTV launched *Andy Warhol's Fifteen Minutes*, that he got his own nationally broadcast show.

Warhol had become friends with Mick and Bianca Jagger, bonding with their daughter, Jade, over art, Monopoly and champagne (she was four at the time) when they rented his Montauk estate. As well as producing the cover for the Rolling Stones' *Sticky Fingers* and *Love You Live*, he was commissioned to make a portfolio of portraits of Mick, to be signed by subject and artist alike, while Bianca became a key social contact. She featured frequently in *Interview*, and persuaded the President's son Jack Ford to do an interview for the magazine in July 1975. Colacello and Warhol accompanied her to the White House for the encounter. Ford's words caused a stir – he said that he would trade places with anybody 'for a penny' as his life was 'stifling' – but it was the photograph of Bianca posing provocatively with him in the Lincoln bedroom that caused the biggest scandal. A romance between the two was rumoured.

Bianca was present at the birth of Studio 54, the hedonistic nightclub and disco that would become Warhol's favourite hangout from its opening in spring 1977. 'I have to go out every night,' he said

in his book *Andy Warhol's Exposures* (1979), and the place he went out to most nights – accompanied by his Polaroid camera and his tape-recorder wife – was the club on West 54th Street run by Steve Rubell and Ian Schrager. Jagger had helped to establish the new nightclub's reputation for orgiastic extravagance when the fashion designer Halston threw a birthday party for her there; she made an appearance on the dancefloor astride a white steed, which had been led out by a couple dressed only in body paint.

An immersive environment, Studio 54 bore comparison to the Silver Factory, and not just because it boasted 1,540 square feet of mirrors. It also offered a unique social mix, thanks to Rubell's highly selective and subjective door policy. His task was akin, he said, to 'mixing a salad or casting a play', to produce just the right combination of 'gay and straight, black and white, rich and poor, uptown and downtown'. Warhol celebrated this 'New Society'. 'The key to the success of Studio 54 is that it's a dictatorship at the door and a democracy on the floor,' he said. 'It's hard to get in but once you're in you could end up dancing with Liza Minnelli.' There was an echo of his own, earlier 'superstar' system in his declaration: 'At 54, the stars are nobody because everybody's a star.'

Studio 54 was highly theatrical, perhaps unsurprisingly since the building had been conceived as an opera house. It still had a fly rail, which was used to raise and lower backdrops – from sunrises and volcanoes to galaxies – that created sudden scenic shifts, 'like a ride at Coney Island'. Fog and snow machines and four hundred different lighting effects added to the drama and glamour. Meanwhile, the unisex bathrooms and lounging banquettes upstairs encouraged hedonistic behaviour. As film and record producer Dave Geffen noted, 'Studio 54 came, crucially, after birth control and before AIDS.' Cocaine was the drug of choice for the partygoers, although Warhol was not tempted. Rather, what gave him a rush at Studio 54

was the voyeuristic opportunity it offered to *watch*. In 1978, he hosted an Oscars party with Truman Capote, to whom, amid Capote's struggles with alcoholism, he had also entrusted a tape recorder and some assignments for *Interview*. The following year, Halston threw a fifty-first birthday party there for Warhol; Rubell gave Andy a present of a garbage pail filled with dollar bills.

Warhol's new social life at Studio 54 alienated Jed Johnson, who felt Andy was wasting his time on 'ridiculous people' there. He now became a successful interior designer and left the house he shared with Warhol in late 1980. His long-time domestic and professional partner affected nonchalance on the subject – 'Jed who?' Andy responded when his studio assistant Ronnie Cutrone said he had seen Johnson in the street afterwards – but the 'so what' mask slipped and Warhol began to drink heavily.

In November 1979, an exhibition of fifty-six portraits of the (mostly) famous faces Warhol had painted in the 1970s – his own mother appeared alongside Liza Minnelli – opened at the Whitney Museum. The critical reception was mixed. Robert Hughes poured scorn on the notion that Warhol had 'revived' social portraiture as a genre; rather, he said he had only 'zipped it into a Halston, painted its eyelids and propped it up in the back of a limo, where it moves but cannot speak'. Meanwhile, in an essay included in the accompanying catalogue, the historian Robert Rosenblum characterized Warhol as the 'Court Painter to the 70s', an artist who, 'despite his legendary indifference to human facts', captured his sitters 'with an incredible range of psychological insights'.

The end of the decade found Warhol in retrospective mood. *POPism*, a memoir of his life and career in the 1960s, was in preparation; this time Pat Hackett would be rewarded with an official co-author credit when the book appeared. In the studio, Warhol was engaged in another exercise in self-historicization in two series

of new-old works. The *Reversals* recycled earlier highlights from his career – *Marilyns, Flowers, Electric Chairs*. The images were silkscreened in reverse, so that they came out mostly black, which gave the works a funereal cast. Another look in the rear-view mirror yielded the *Retrospectives*, which mixed assorted Warhol images on very large canvases.

After his near-fatal shooting in 1968, Warhol had expressed the fear that he was now just imitating himself. That was certainly true of these projects. With the 1980s fast approaching, what would the way forward be creatively?

9

Refreshing the Brand

I n art-critical terms, Warhol had a poor 1970s. The decade had ended with the celebrity portraits show at the Whitney, while early in the new decade an exhibition of dollar-sign paintings in Castelli's Greene Street basement space caused Stuart Morgan to declare in *Artforum*: 'In recent years his shows have been increasingly disappointing… Warhol's work has always been empty, but now it seems empty-headed.' The *Dollar Signs* did not translate into dollars either: not a single work in the show sold.

Politically, Warhol was in trouble with his former supporters again for putting Nancy Reagan, the new First Lady, on the cover of *Interview* after attending the Republican President's inauguration in January 1981. The *Village Voice* ran a parody in which Warhol and Colacello went to see Hitler in his bunker and pitched him 'soft ball' questions. Warhol was aware that he had become trapped in the persona he had created for himself, and sometimes expressed a desire to escape the largely self-drawn caricature. His mansion on East 66th Street offered some respite. 'Sometimes it's so great to get home and take off my Andy suit,' he said.

In truth, between all the portraits of German industrialists and their wives, the late seventies had been a period of restless artistic experimentation for Warhol. Part of the impetus for this renewed questing was provided by a visit to Paris to attend the opening of the Centre Pompidou in 1977. After taking a tour with the museum's founding director, Pontus Hultén, who had curated his Moderna Museet retrospective in Stockholm in 1968, Warhol confided in

his *Diaries*: 'I had energy and wanted to rush home and paint and stop doing society portraits.' Another spur to activity may have been provided by the onset of a midlife crisis: Warhol turned fifty in August 1978.

A skull purchased in a flea market in Paris became the basis of some of his best paintings of the period, and the only ones to make it into *Andy Warhol's Exposures*. Both Fred Hughes, who was always concerned with pleasing Warhol's uptown clients, and Ronnie Cutrone, better attuned to more bohemian notions of cool, approved of the *Skulls*, which could be seen as both cerebrally classical and nihilistically punk.

The *Hammer and Sickle* paintings underscored Warhol's leftist credentials, although perhaps only ironically. When the exhibition opened at Leo Castelli Gallery in January 1977 – his first show of new work there for eleven years – some started calling him 'Comrade Andy', though Warhol insisted that the subject matter had no political significance for him. The inspiration, he explained, had come from seeing the Communist Party symbol graffitied on walls in Rome, and he had simply liked 'the look'. 'That sort of makes it Pop, in a funny way,' explained Cutrone. 'It sort of loses its political meaning when you see so many of them. It becomes like... decoration.'

Warhol mockingly suggested that it might be best not to think of his most abstract series of the period, the *Shadows*, as art at all. He pointed out that the opening party in January 1979 had featured disco music, so 'I guess that makes them disco décor,' he concluded. The installation at the Heiner Friedrich Gallery in SoHo presented the paintings in a tight, interlocking sequence around the walls so that they encircled visitors in a kind of 'cinematic progression'. Produced when Warhol was most assiduously attending Studio 54, the *Shadows* have been seen as a comment on the void at the heart of that hedonistic scene.

As with the other series of this period, the *Shadows* were generated not from found images but from photographs taken in the studio. No one was quite sure what the object casting the shadow was in this case – among other things, an aroused penis has been suggested – but the shift towards abstraction was striking. Warhol had always been the master of painting instantly recognizable subject matter – the best-known household objects, the most famous faces – whereas he was now working in ways that recalled the methods and effects of the Abstract Expressionists. There was punky humour and mischief in these references. For instance, the so-called 'Piss Paintings', or *Oxidation* series, were made by urinating on canvases primed with copper pigment, which, on exposure to the acids in the fluid, would undergo a chemical reaction and change colour. Where Jackson Pollock had produced his spattered canvases by indulging in deep spiritual self-searching, Warhol had made his by simply taking a pee.

With conceptualism and minimalism to the fore, the New York art scene of the 1970s was not particularly hospitable to Warhol's brand of hyper-visuality. The Reagan decade would provide him with more fitting company when the Neo-expressionists – Julian Schnabel, Francesco Clemente, Jean-Michel Basquiat and others – burst on to the stage. It was a good moment for Warhol, or 'Grandma', as he was now known at the studio, to re-enter the scene.

For this new generation, Pop was a major influence and Warhol, the 'Pope of Pop', was a hero. 'He was the father, and we were the children,' said Kenny Scharf. 'Had Andy not broken the concept of what art is supposed to be, I just wouldn't have been able to exist,' explained Keith Haring, who would strike up a friendship with Warhol and pay homage to him in his *Andy Mouse* works: 'He sort of made this niche for himself in the culture. As much as Mickey Mouse had.'

But it was Basquiat who would have the biggest impact on Andy's own practice. It was he who seemingly convinced Warhol to return

to painting by hand, and Warhol certainly acknowledged a positive influence from the younger artist. 'Jean Michel got me into painting differently, so that's a good thing,' he noted in his *Diaries*. They made playful portraits of each other; Basquiat offered a homage to Warhol in the form of a painting of a peeled banana on a silver ground, which formed the centrepiece of his first one-man show, at the Mary Boone Gallery in May 1984, while Warhol did one of Basquiat in his briefs as Michelangelo's *David*. They even exchanged hair. Basquiat mounted some of his cropped locks on a helmet – 'It looked great,' said Warhol – while Andy presented the younger artist with one of his wigs, framed.

From autumn 1984 to summer 1985, Basquiat and Warhol worked together on a body of work that would be shown at the Tony Shafrazi Gallery, and the young artist came to Warhol's 33rd Street studio most afternoons. Warhol would screen logos on to a canvas and Basquiat painted over the ground with his characteristic graffiti symbols and faces. Warhol was particularly excited when the final effect made it hard to tell which artist had done what, as in *African Masks* (1984), which Warhol called a masterpiece. As Bob Colacello later commented, 'Two artists signing one painting – what could be more Warholian?'

The two artists were photographed sparring in boxing gear to promote the Shafrazi show, and across a lengthy period actually went to the gym together – there is a Basquiat acrylic of Warhol lifting weights – not to mention the manicurist's ('And you know, my nails are getting better,' Warhol said in his *Diaries*. 'The two of us would make a good story for *Vogue*'). They socialized in the evenings. They went to performances by Basquiat's former girlfriend Madonna ('she's thinner,' noted Warhol) and by Boy George ('so fat'; Warhol said he found it hard to enjoy the former Culture Club singer's show because the experience reminded him of what Jackie Curtis might have achieved). Then there was a meeting with Michael Jackson, with

whom Warhol described an 'anticlimactic' encounter that involved little more than a handshake ('The sequined glove isn't just a little sequined glove, it's like a catcher's mitt').

Basquiat moved into the carriage house of a property owned by Warhol on Great Jones Street, and Andy provided the younger artist with advice: for instance, to keep hold of some of his early works as a 'nest egg' so that he could sell them later when his prices rose. Warhol also said that Basquiat came to him for 'philosophy' to deal with his fear that his success might prove short-lived. Warhol reassured him, although he typically expressed private anxieties about Basquiat's inability to pay the rent on his carriage house should his career tail off. Money was always on Andy's mind.

Basquiat dated Paige Powell, a Warhol employee who worked as an advertising associate and then as associate publisher on *Interview*. Warhol reported her being upset to discover that Basquiat was using heroin. Cutrone thought Warhol was 'happy to be around a young drug addict again', as it reminded him of the Silver Factory years. But Basquiat's narcotics use was a source of concern to Andy when it affected his ability to function as an artist. On one occasion he complained about Basquiat painting over Francesco Clemente's contribution to a canvas they were all working on together: 'And he was in slow motion so I guess he was on heroin. He'd bend over to fix his shoelace and he'd be in that position for five minutes.'

By September 1985, when the show of their collaborative work opened at the Tony Shafrazi Gallery, the relationship between the two artists was souring, and Basquiat failed to attend the celebration dinner afterwards at Mr Chow's. The critical response to the exhibition was negative, with the *New York Times* most damagingly referring to Basquiat as Andy's 'mascot'. 'Oh God,' noted Warhol in his *Diaries*. They did not work together again, but they continued to communicate.

It had always been a complicated relationship. 'To most people Jean-Michel dominated Andy – Andy had been victimized,' noted Emile de Antonio. 'But I saw it quite the other way.' Cutrone said it 'was like some crazy art-world marriage… Jean-Michel thought he needed Andy's fame, and Andy thought he needed Jean-Michel's new blood. Jean-Michel gave Andy a rebellious image again.' Glenn O'Brien thought there was real affection between the pair, saying that Warhol 'loved Jean-Michel like a son almost'. Some even suggested there was a sexual relationship between them, although that seems improbable.

Whatever the case, Basquiat, his career suddenly in abeyance, would be badly affected by Warhol's death in 1987. He continued to live in Great Jones Street until he died from an overdose in August 1988. It was in Warhol's old carriage house that his body was discovered.

After the departure of Jed Johnson towards the end of 1980 (they shared custody of their dachshunds Archie and Amos), Warhol remained partnerless until he met Jon Gould. Andy's obsession with the handsome vice president of production for Paramount Pictures in New York, who was twenty-five years his junior, is evident in the number of photographs he took of him; Gould is his most documented subject of this period. His amorous sufferings early in their relationship are evident from entries in his *Diaries*, where he detailed his struggle to live up to his own 'so what' philosophy. Reading of his travails, it is hard not to think that he was in earnest when he later declared himself a 'romantic'. '[Jon] said he'd call me and didn't, which was mean. I have to pull myself together and go on,' he said on 12 June 1981. '…I don't know what to do. I watched *Urban Cowboy*, and John Travolta just dances so beautifully. It was a really good movie. A Paramount movie, so that made me think more about Jon and I felt worse. I cried myself to sleep.'

Their relationship developed nonetheless. In late 1984, they were living together when Gould was diagnosed with AIDS; he was hospitalized briefly in early 1985 and Andy paid him daily visits. Meanwhile, fearing that he might contract the virus himself, Warhol instructed his housekeepers, Nena and Aurora, to wash his and Gould's dishes and clothes separately. After moving to LA, Gould died the following year, on 19 September 1986, when Andy noted his passing indirectly in his *Diaries* by recording that another Paramount employee had been given a job at Twentieth Century Fox: 'And the Diary can write itself on the other news from L.A., which I don't want to talk about.'

Andy had not entirely given up on society. He attended the LA wedding of Madonna and Sean Penn as Keith Haring's plus one on 16 August 1985, and the nuptials of Maria Shriver and Arnold Schwarzenegger in Hyannis Port, the Kennedy summer residence on Cape Cod, on 27 April 1986. The latter drew the 'cream of the New England establishment', noted Eva Windmöller, an 'élite mixture of power, money, beauty and fine living'. Joining the assembled society throng from the back of a limousine was 'an incredible couple: pop singer Grace Jones, in a strident purple fur, and Andy Warhol in black leather, the inevitable rucksack on his back'.

Business was good. *Interview* was thriving, his cable show was gaining ground, he was shooting music videos for MTV, and his face was in demand from advertisers and casting directors; in autumn 1985, Warhol went to Los Angeles to act in the popular TV series *The Loveboat* and pulled in a Diet Coke commercial while he was there. The artist famous for his collection of wigs did ads for Vidal Sassoon hairspray from 1984 to 1986.

Warhol was maintaining a strong, perhaps even obsessive, health regime. He got collagen shots from one doctor, and nutrition advice

from another – Drella was now a major consumer of garlic. Crystals became a central part of his daily routine: he wore a crystal pendant to help 'tune him in to the cosmos' and put crystals in the pot when he brewed herbal tea. But he was suffering with his gallbladder, and continued to ignore medical advice that he should have it removed, steadily refusing to submit to hospitalization.

Towards the end of 1985, a new book, *America*, was published by Harper & Row. Consisting of two hundred and fifty and more of Warhol's snapshots of the famous and the overlooked, from Madonna to the backs of beauty contestants and the homeless, as well as landscapes, it was an attempt at a photographic survey of coast-to-coast national life along the lines of Robert Frank's *The Americans*. Warhol was dissatisfied with the initial text and had it improved by Pat Hackett; key passages were drawn from earlier publications, including a modified version of his famous Coca-Cola riff. Warhol never seemed entirely satisfied with the result. 'I can't remember what I said. I can't remember the pictures either,' he said on the accompanying publicity tour.

Among the more resonant lines in *America* are Warhol's (or Warhol-Hackett's) reflections on death. Recalling Solanas's assassination attempt, he says: 'I always wished I had died, and I still wish that, because I could have gotten the whole thing over with.' As the AIDS epidemic (or 'gay cancer,' as Warhol called it in his *Diaries*) gripped, many of his friends were 'getting the whole thing over with', while drink had recently taken Truman Capote, drugs had claimed Jackie Curtis and a heart attack would soon kill his artist friend Joseph Beuys. Death was all around him.

10

Last Suppers
and Last Rites

On 2 April 1980, Warhol and Fred Hughes flew to Rome from Naples for a 'private audience' with the Pope. Not that the occasion was particularly private; there were five thousand other people in attendance, according to the account in the *Diaries*. Nor did Warhol find it especially interesting. Pope John Paul II delivered a three-hour speech against divorce in seven languages, he noted, to the accompaniment of cheerleaders going 'Rah-rah, pope'. Warhol signed autographs for some nuns, but grew worried when he was recognized by one who reminded him of Valerie Solanas. He was relieved to get away after receiving a blessing. But although he showed little sign of having been filled with the Holy Spirit – 'It was really boring,' he observed impassively – he had taken the occasion seriously and dressed respectfully. It was not just that he wore a plain tie; he also donned a noticeably smart and sober wig.

How religious was Andy? Thanks to his parents' devotion, Catholicism was as much a part of his childhood as Campbell's soup. He did not leave his faith behind when he left Pittsburgh, either. In New York, his inner circle, from Gerard Malanga to Fred Hughes and Paul Morrissey, shared a Catholic upbringing. And of course he continued to live with his mother: every day before he set off for the Factory, they would pray together in Old Slavonic.

When he was shot, Viva and Brigid Berlin went to Warhol's Lexington Street house and were surprised to discover religious statues and a crucifix over his four-poster bed. He was pleased to finance his nephew's studies for the priesthood, and he seems to have

been in the habit of carrying a rosary and a small missal in his pocket. Quizzed about his church-going habits in *Interview* in 1975, he said that he took communion sometimes, although 'I never feel that I do anything bad.' Not that he said much about personal spiritual illumination, preferring, characteristically, to stick to surfaces and superficialities. 'I think it's really pretty to go to church,' he said. 'The church I go to is a pretty church.' Perhaps his religious commitment deepened with age. He now attended weekly Mass at St Vincent Ferrer on East 66th and Lexington, and helped out at the Church of the Heavenly Rest, pouring coffee for the poor and homeless.

It so happened that Warhol's final show would be based on a Catholic Renaissance masterpiece. In 1984, Alexandre Iolas, the Greek-American art dealer who had given him his first New York show in 1952, commissioned him to make a series based on Leonardo da Vinci's *Last Supper*. When asked whether the theme meant anything in particular to him, Andy responded: 'No. It's a good picture.' But it was an image that had been familiar to him from his early childhood: there had been a reproduction of it on the Warholas' kitchen wall in Pittsburgh, and his mother kept another in her Bible.

Warhol worked on the theme obsessively for over a year, although the exhibition would feature only a modest proportion of the more than a hundred pieces he produced. There were works on paper, large-scale paintings and even a sculpture, *Ten Punching Bags (Last Supper)* (1985–86), a collaboration with Basquiat. Typically, the starting point was mass-produced copies of the faded masterpiece rather than Leonardo's original; sources included a polychrome plaster model found in a local market and a line engraving that Warhol projected and repainted freehand, incorporating symbolic contemporary emblems: a $6.99 price tag, a newspaper headline reading 'The Big C' (Christ and cancer).

The result was one of the biggest and most ambitious series of religious works produced in the twentieth century, created at the height of the AIDS crisis. Indeed, Iolas himself was suffering from the disease and would die from related complications shortly after the exhibition closed. Warhol is generally thought to have distanced himself from the 'gay cancer', but some have seen in *The Last Supper* 'a confession of the conflict he felt between his faith and his sexuality'. According to Jessica Beck, in the series he 'gave AIDS a face – the mournful face of Christ'. Warhol was clearly reflecting deeply on the theme at the time; this was also the period when he produced works such as *AIDS, Jeep, Bicycle, Heaven and Hell Are Just One Breath Away!, The Mark of the Beast* and *Repent and Sin No More!* (all 1985–86). In many ways, Warhol's works of these years could be seen as heralding the onset of the great flourishing of AIDS activism; Larry Kramer founded the AIDS Coalition to Unleash Power (ACT UP) in March 1987.

Away from the studio, Andy was spending a lot of time trying on wigs. He had several hundred in his bedroom, and he would sit alone in front of a large oval mirror modelling them. Something about the wild, discomposed look appealed to him now – perhaps it reflected his inner state – and his hairpieces grew more disordered and spiky as a consequence.

In July 1986, Warhol presented his 'Fright Wig' self-portraits in London at Anthony d'Offay Gallery. It was the only exhibition devoted to self-portraiture of his career. The launch was an emotional occasion. 'When Andy walked into the reception, lots of people burst into tears,' remembered d'Offay. 'Andy Warhol was not just the world's most famous artist; he was an art hero, someone in whose life you perceive something extraordinary and brave.' Few, if any, artists' faces were more instantly recognizable than Warhol's, thanks to his distinctive series of self-portraits as much as his media

appearances. In all these works, Warhol could be said to be wearing a mask of one kind or another.

In 1963–64, in a series of photo-booth self-portraits made at the moment of his emergence as the presiding deity of the upstart Pop movement, Warhol presented a gangsterish figure, hidden behind dark glasses. Then there were the shadowy, coolly appraising self-portraits of 1967, showing a more established, if still enigmatically unknowable and inscrutable figure, standing somewhat aloof as a commentator on the new consumer society. Then, at the beginning of the 1980s, there had been the drag alter ego portraits, a homage to Duchamp's Rrose Sélavy. But these new self-portraits were different. Now, hollow-cheeked, his eyes open but vacant, his hair wild and spiked, in the 'Fright Wig' self-portraits of the d'Offay show he seemed almost to be wearing a death mask. 'The new painting is like Warhol's great self-portraits of the sixties, candid and disturbing,' wrote the curator John Caldwell. 'It is, in a sense, too self-revealing; he looks simultaneously ravaged and demonic, blank and full of too many years and too much experience… we feel that Warhol himself, like his self-portrait, is imminently perishable.'

The *Last Supper* show, entitled *Warhol – Il Cenacolo*, would follow in January 1987, housed in the refectory of the Palazzo delle Stelline, Milan, opposite the site of the original mural of *The Last Supper* in the Dominican cloister of Santa Maria delle Grazie. Warhol flew in for the show's opening, but was uncomfortable at the celebration dinner and went back to his hotel exhausted. He developed a fever, which he attributed to the flu, but his gallbladder condition had worsened recently and he was now eating very little. On the plane back to New York he marked what he called 'a milestone': 'I was in the *International Herald Tribune* and I didn't even bother to clip the article.' Another milestone: he then failed to get a receipt from his taxi driver for the ride home from the airport. For Warhol not to

bother with documenting his own fame or spending, he must, as he said in his *Diaries*, have been feeling genuinely unwell.

On 17 February, he taped a fashion show with Miles Davis, holding the jazz trumpeter's coat-tails as he wove a path down the runway at the Tunnel, a club in the East Village. Visibly in pain, Warhol left as soon as he could and cancelled his dinner appointment afterwards. The following day, he consulted his doctor, who told him that his gallbladder was infected. Andy wanted to avoid an operation at any cost – was there no home treatment that could be attempted? – but was advised that he had to have the organ removed urgently: 'they told me I'll die if I don't,' he reported to Pat Hackett.

Accepting the inevitable, he checked into New York Hospital on Friday, 20 February. Typically, he asked at reception whether any famous people were staying there and then signed in under an assumed name ('Bob Robert', although he would have preferred 'Barbara') to avoid publicity. For company, he had a copy of Kitty Kelley's *His Way: The Unauthorized Biography of Frank Sinatra*, a book about the Supremes and a copy of *TV Guide*. He was assured that it was a routine operation and he would be home again on Sunday, so he told Paige Powell not to cancel their ballet tickets for that night. But he also expressed foreboding to friends; he had often said that if he went into hospital again, he would not come out alive.

The operation took place on the Saturday. Warhol's gangrenous gallbladder fell apart as it was removed, but no complications were noted in surgery and Warhol was returned to his room, where he recovered sufficiently to make telephone calls before falling asleep peacefully in the evening. Then, as night edged towards morning, the nurse noticed that he had turned blue; an attempt was made to insert a tube into his windpipe, but rigor mortis had set in.

Andy Warhol was pronounced dead, for the second time, at 6:31am on Sunday, 22 February 1987.

Epilogue

'Figment'

Warhol's funeral service was held at the Holy Ghost Byzantine Catholic Church on the north side of Pittsburgh on 26 February 1987. His body was dressed in a paisley tie and black suit, a platinum wig and pair of sunglasses were placed on his head and face, and in his hands were put a small black prayer book and a red rose. No famous guests were present – this was a private affair – as Monsignor Peter Tay delivered his eulogy: 'Though it seems at times that he wandered far from his church, we do not judge him. Jesus forgave the thief on his right. He did not forgive the thief on his left,' he added, ambiguously. '… It means there is always hope, but it also means nobody should take salvation too much for granted.' Warhol's body was transported south to St John the Divine Cemetery in Bethel Park, for burial next to his parents. The priest offered a brief prayer and sprinkled holy water over the coffin; Paige Powell dropped a copy of *Interview* and a bottle of perfume, Estée Lauder's 'Beautiful', into the grave – votive offerings – as the casket began to be lowered.

Lots of famous people turned up to Warhol's memorial service, held at St Patrick's Cathedral in New York on 1 April 1987. Two thousand mourners, including Halston and Liza Minnelli, heard a pianist play a passage from Mozart's opera *The Magic Flute* – the entrance of the high priest, Sarastro – and Brigid Berlin read from the Book of Solomon. In his eulogy, the art historian John Richardson said Warhol 'fooled the world into believing that his only obsessions were money, fame, and glamor and that he was

cool to the point of callousness'. But, he noted, he went to Mass 'more often than is obligatory': 'The callous observer was in fact a recording angel... In his impregnable innocence and humility Andy always struck me as a *yurodstvo* – one of those saintly simpletons who haunt Russian fiction and Slavic villages.'

At auction at Sotheby's New York in April 1988, the saintly simpleton's relics, cookie jars and all, fetched $5.3 million.

'It is an amusing contradiction,' said his friend Henry Geldzahler, 'that Andy, who so loved gossip and celebrity culture, timidly shielded his own private life and the private meaning of his work from public scrutiny.' Sex, said Warhol, was 'abstract'. Ditto death. As for his work, it was as deep as he was – that is, not at all. It was pure surface. That is: Andy Warhol, 'Nothingness Himself' (Jonas Mekas).

'I always had this philosophy of "It doesn't really matter." It's an Eastern philosophy more than Western,' one of Warhol's great ventriloquizers, Gretchen Berg, had Andy say in 1966. 'It's too hard to think about things.' What did matter to him, even if he refused to explain it, was work. ('All that matters is work,' another of his ventriloquizers, Lou Reed, had him say in *Songs for Drella*.) And how much work there is: the drawings, paintings and sculptures, of course, then 472 *Screen Tests*, 4,000 videos, 70 films, 3,000 audiotapes, 610 *Time Capsules*, nearly two decades of *Interview* magazine, the more-than-1,000 pages of the *Diaries*, the books, the TV broadcasts, the album covers, the Exploding Plastic Inevitable performances.

In *America* (1985), Warhol – or one of his ventriloquizer-doubles, Hackett perhaps – wrote: 'I never understood why when you died, you didn't just vanish, and everything could just keep going the way it was only you just wouldn't be there. I always thought I'd like my own tombstone to be blank. No epitaph, and no name. Well, actually, I'd like it to say "figment".' Two years after his death, Warhol finally realized one of his greatest ambitions: he was given a

retrospective at the Museum of Modern Art. And Andy was present for the opening party. As music by the Velvet Underground played and guests wandered among the works, there he stood, the Pope of Pop, in his familiar platinum-white wig and glasses. Or was it actually that Warholian figment, Allen Midgette, who had impersonated him on college campuses in the 1960s?

'It really does not matter,' Warhol might have shrugged. 'So what.'

Further Reading

Books by Andy Warhol

a (a novel), 1968

THE Philosophy of Andy Warhol: From A to B and Back Again, 1975

– and Bob Colacello, *Andy Warhol's Exposures*, 1979

– and Pat Hackett, *POPism: The Warhol Sixties*, 1980

America, 1985

The Andy Warhol Diaries, ed. Pat Hackett, 1989

Books about Andy Warhol

Callie Angell, *Andy Warhol: Screen Tests. The Films of Andy Warhol (Catalogue Raisonné, Volume 1)*, 2006

Victor Bockris, *The Life and Death of Andy Warhol*, 1989/1997/2003

David Bourdon, *Warhol*, 1989

Bob Colacello, *Holy Terror: Andy Warhol Close Up*, 1990

Rainer Crone, *Andy Warhol: A Picture Show by the Artist. The Early Works 1942–1962*, 1987

Arthur C. Danto, *Andy Warhol*, 2009

De Salvo, Donna, ed., *Andy Warhol: From A to B and Back Again*, 2018

Jennifer Doyle, Jonathan Flatley and José Esteban Muñoz, eds, *Pop Out: Queer Andy*, 1996

Gary Garrels, ed., *The Work of Andy Warhol*, 1989

Kenneth Goldsmith, ed., *I'll Be Your Mirror: The Selected Andy Warhol Interviews, 1962–1987*, 2004

Michael Dayton Hermann, ed., *Warhol on Basquiat*, 2019

Dave Hickey et al., *Andy Warhol: 'Giant' Size*, 2006

Klaus Honnef, *Warhol*, 2015

Joseph D. Ketner II, *Andy Warhol*, 2013

Wayne Koestenbaum, *Andy Warhol: A Biography*, 2003

Isabel Kuhl, *Andy Warhol*, 2013

Colin McCabe with Mark Francis and Peter Wollen, eds, *Who Is Andy Warhol?*, 1997

Kynaston McShine, ed., *Andy Warhol: A Retrospective*, 1989

Eva Meyer-Hermann, *Andy Warhol: A Guide to 706 Items in 2 Hours 56 Minutes*, 2007

Astrid Johanna Ofner, ed., *Andy Warhol: Filmmaker*, 2005

Stephen Shore and Lynne Tillman, *The Velvet Years: Warhol's Factory, 1965–67*, 1995

Patrick S. Smith, *Warhol: Conversations about the Artist*, 1988

Gilda Williams, ed., *On&By: Andy Warhol*, 2016

Index

Index

Index

Index

Acknowledgements

With thanks to the staff at Laurence King Publishing, in particular Gaynor Sermon, Donald Dinwiddie, Peter Kent, Marc Valli, Mariana Sameiro and Nicola Hodgson.

Picture Credits

1. Photo by Ken Heyman/Woodfin Camp/The LIFE Images Collection via Getty Images
2. Photo by Herve Gloaguen/Gamma-Rapho via Getty Images
3. ©Burt Glinn/Magnum Photos
4. Everett Collection Inc./Alamy
5. Photo by Santi Visalli Inc./Getty Images
6. Bernard Gotfryd/Getty Images
7. 2094464/Globe Photos/MediaPunch/Alamy
8. Library of Congress
9. Photograph ©Nat Finkelstein Estate
10. Photo by Fred W. McDarrah/Getty Images
11. Granger Historical Picture Archive/Alamy
12. David Montgomery/Getty Images
13. Jack Mitchell/Getty Images
14. AF archive/Alamy
15. Robin Platzer/Twin Images/The LIFE Images Collection via Getty Images
16. Marka/Alamy
17. Sonia Moskowitz/Getty Images
18. AF archive/Alamy
19. DMI/The LIFE Picture Collection via Getty Images
20. Lionello Fabbri/Science Source
21. Photo by Ron Galella/Ron Galella Collection via Getty Images